IMAGES
of America

SWEDES OF GREATER
WORCESTER REVISITED

No. 3534

UTVANDRARE-KONTRAKT

emellan

JOHN ODELL Göteborg, befullmäktigad utvandrare—Agent samt nedanstående utvandrare:

Jag JOHN ODELL, förbinder mig härmed att, på sätt här nedan närmare imförmäles från Göteborg till *Boston Mass.* Nord-Amerika befordra nedan antecknade utvandrar mot en redan till fullo erlagd och härmed qvitterad afgift af Kr. *210.—* hvari jemväl inräknats de vid landning i Amerika förekommande afgifter af allmän beskaffenhet.	I JOHN ODELL hereby undertake, upon the following terms, t forward from Gothenburg to *Boston Mass.* in North America, the emigrant named below for the sum of *Kr. 210* which amount has bee duly paid and includes all ordinary charges upon landing i America

Resan sker från Göteborg den *5/4* med Ångfartyg å mellandäcksplats till Hull i England och derifrån senast inom 48 timmar efter slutad tullexpedition med jernväg å 3:dje klass till Liverpool, eller London samt från Liverpool eller London senast inom 12 dagar, efter utvandrarens ankomst dit, med ocean-ångare å mellandäcksplats till Newyork i Nord-Amerika. Från Newyork befordras utvandraren genast efter slutad tullexpedition och öfriga formaliteter med 3:dje klass till *Boston Mass.*

För ofvansagde afgift erhåller utvandraren, utan vidare ersättning, god och tillräcklig kost jemte vård från Göteborg till landstigningsplatsen i Amerika, logis under uppehållen i England och befordran och vård af reseffekter till 10 kubikfots utrymme å Ångfartyg och 100 skålp. vigt å jernväg. För barn mellan 1 och 12 år befordras reseffekter fritt endast till hälften af hvad nu sagts till Amerika, hvarest ingen fri befordran af reseffekten för barn under 5 år eger rum.

Utvandraren är berättigad att bekomma kontramärke å de effekter, som han ej sjelf har om hand, och erhåller för desamma, som utgöra *N:o 1712* ...lly och äro märkta med N:o... ...tning till ett belopp af högst kronor ...tio, för hvar je passagerare öfver 12 år, samt högst tjugofem kronor för barn emellan 1 och 12 år, derest effekterna icke vid landstigningsplatsen i Amerika riktigt utbekommas mot återlemnande af sagde kontramärke.

I den händelse detta kontrakt af mig ej skulle uppfyllas, eller om misstydning å någondera sidan möjligen komme att uppstå, underkastar jag mig de bestämmelser som innehållas i § 5 § 6 mom. af Kongl. Förordningen den 4 Juni 1884.

Anser sig utvandrare haft anledning till klagan deröfver att han icke åtnjutit den rätt och de förmåner, som på grund af detta kontrakt bort honom tillkomma, bör anmälan derom göras hos vederbörande Konsul så fort omständigheterna medgifva.

Utvandrarnes namn.	Ålder.	Senaste vistelseort.
Oskar F. Carlson	29	Skinskat...
Hustr. Erika	22	—
		Westm...
		2...
		Boston...

The journey takes place from Gothenburg the *5/4* by steamer steerage passage to Hull in England and thence, within 48 hours after having passed the customs, to Liverpool or London by rail, 3rd class and from Liverpool or London within 12 days after arrival there, by Ocean steamer steerage passage, to New York in North America. From New York the Emigrant will be forwarded, immediately after having passed the customs and complied with other formalities, by 3rd class to *Boston*

At the abovementioned fare the emigrant will be supplied with good and sufficient provisions and attendance from leaving Gothenburg until arrival at place of landing in America, lodging during the stay in England and conveyance and care of effects not exceeding 10 cubic feet space by steamer and 100 lbs. weight by rail way. Effects of children between 1 and 12 years carried free at the rate of half of what has been before stated for effects to America, where no free conveyance of effects of children under 5 years is allowed.

The emigrant is entitled to a check for such effects as are not under his own care, and will receive for same consisting of ____ package and numbered ____ a compensation, not exceeding Kronor 50, per adult in the event of their non-delivery on surrender of said check upon arrival at place of landing in America.

In case of non-fulfilment of this contract by me or misinterpretation on either side should arise I agree to submit the provisions contained in paragraph section 6 of the Royal Ordinance of the 4th June, 1884.

If the emigrant has any reason for complaint of not being treated in accordance with the terms stipulated in this contract, a report thereof should be made to the nearest Consul as soon as circumstances admit.

Göteborg den *4 April* 188*9*

JOHN ODELL,

Antages:

Oskar Carlson

Uppvisadt och godkändt sasom upprättadt i öfverensstämmelse med Kgl. Förordningen den 4 Juni 1884, intygas.

Göteborg i Poliskammaren den *5/4* 188*9*

Västmanland natives Oskar F. and Ericka Carlson purchased passage to the United States in 1889. Their trip took them from the Swedish port city of Göteborg to England, where they boarded their ship bound for Boston. Shown here is their contract, purchased through one of the numerous agents who made a lucrative business from the emigrant market.

IMAGES
of America

SWEDES OF GREATER WORCESTER REVISITED

Eric J. Salomonsson, William O. Hultgren,
and Philip C. Becker

ARCADIA
PUBLISHING

Published by Arcadia Publishing,
Charleston, South Carolina

Printed in the United States of America

Library of Congress Catalog Card Number: 2004115617

For all general information, contact Arcadia Publishing:
Telephone 843-853-2070
Fax 843-853-0044
E-mail sales@arcadiapublishing.com
For customer service and orders:
Toll-Free 1-888-313-2665

Visit us on the Internet at www.arcadiapublishing.com

On the cover: Before the vestry of the Zion Lutheran Church was completed in 1916, congregants held services at the Greendale Improvement Society Hall. In the photograph, congregants pose at the hall (on West Boylston Street) shortly after the organization of the church in the fall of 1914.

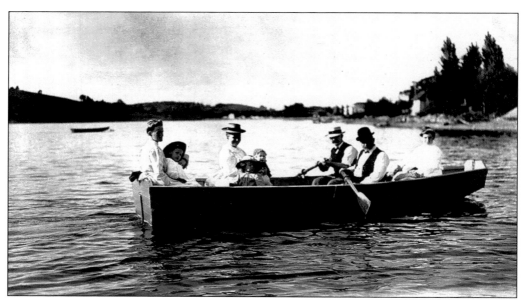

North Pond (now Indian Lake) in Worcester is a favorite destination for area residents. In this *c.* 1904 photograph, Västmanland native Carl A. Carlson (in derby, second from right) and his wife, Esther (in hat, third from left) enjoy a leisurely summer boat ride with friends on the calm waters of the lake.

CONTENTS

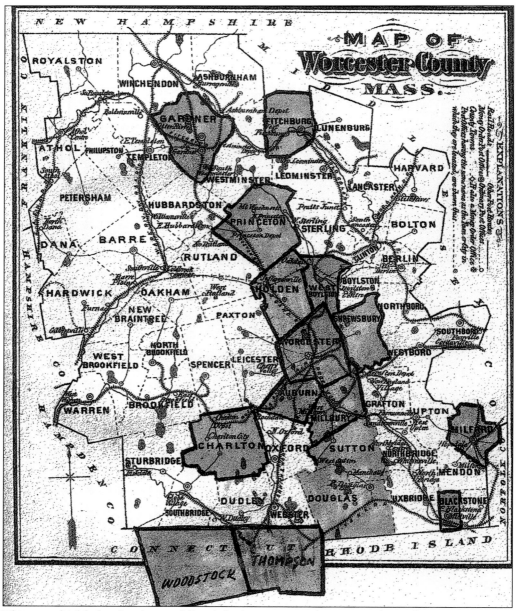

This map highlights localities of Swedish American settlements and social organizations. A minor Swedish presence existed within this region as early as the 17th century. It was the advent of the industrial age, however, that had truly become the catalyst for large-scale Swedish immigration by the late 19th century. By the first quarter of the 20th century, the territory had become a Swedish American stronghold.

INTRODUCTION

The Swedish American story of central Massachusetts was highlighted in the 2002 Arcadia publication *Swedes of Greater Worcester*. The material and images gathered for that volume grew to such an extent that the authors now present an additional publication. Furthermore, the geographic area has been expanded to include Swedish sites throughout Worcester County. The smaller Swedish settlements in northern Windham County, Connecticut, and even Woonsocket, Rhode Island, are also represented. The ethnic community transcends geographical boundaries. In this companion volume, a wide range of images captures the everyday life of the immigrant generation and subsequent American-born descendants. These images take the reader into the homes, churches, societies and clubs, factories, and businesses of the Swedish Americans.

Despite covering several facets of the community, this pictorial history is limited by both time and format constraints. The authors realize there remains many aspects of the regional Swedish American community that have yet to be documented and it is their sincere hope that future generations will continue to record and preserve the Swedish American story.

Interspersed within this book are numerous images of the Swede-Finn community. Between the 12th and 19th centuries, until it was lost to Russia during the Napoleonic wars, Finland was under Swedish rule. During that time, ethnic Swedes settled the eastern region of the Gulf of Bothnia, known as Österbotten. In modern-day Finland, Swedish-speaking districts are still numerous in this province. Between 1870 and 1930, it is estimated that nearly 85,000 Swede-Finns immigrated to North America. In relationship to the Swedish and Finnish communities, the Swede-Finns are a smaller population but are nonetheless an important element in the history of Scandinavian Americans in Worcester County.

Central New England, especially Worcester County in Massachusetts and the adjacent northern Windham County in Connecticut, were major areas of Swedish settlement. Immigrants established themselves in these areas for a variety of reasons, but one spoke for many when he wrote home to Sweden in 1905, "Here we may have a boss, but never a master." Self-betterment was the principal reason for the Swedes having left the old country to settle in the promising land to the west. Worcester's grinding wheel and abrasive industry, which soon grew to become the largest in the world, attracted thousands of Swedish workers, while the steel mills brought hundreds more from the mining districts of central Sweden. Soon, professional men and tradesmen skilled in the pattern industry arrived and established shops throughout the region. Businesses opened that catered to the Swedish population: the Swedish Cemetery Corporation was founded, in addition to a Swedish credit union, a nursing home, and a hospital. The word of God was preached in numerous Swedish-organized denominations. By the beginning of the 20th century, numerous Swedish-language publications kept readers informed of the happenings within the ethnic community, which by then had grown into one of the largest concentrations in the eastern United States.

The late 19th and early 20th centuries were an era of intense ethnic and social rivalries. As such, each ethnic group sought to portray itself in the best possible light, in hopes of finding favor with the established American hierarchy. Thus, leaders within the Swedish American community

capitalized upon their so-called "inherent" values of Protestantism, Republicanism, and aversion to alcohol. Beneath this layer of self-promotion, however, existed thousands of ordinary individuals who more accurately reflected the day-to-day life of the Swedish Americans.

Although tied to their ethnicity through various religious, social, benevolent, and fraternal organizations, Swedish Americans were also influenced by American society on a daily basis, and they became active participants in mainstream life. Many immigrants became citizens and participated in the political process. American holidays were celebrated, while fads, popular culture, and national trends affected the psyche as well. Subsequent generations were born and raised in the United States, and thus direct ties to the old homeland weakened.

During the post–World War II era, mainstreaming of the ethnic community continued. Already by this time, most of the Swedish congregations had gone over to English and dropped "Swedish" from their respective names. Many second- and third-generation Swedish Americans left the old neighborhoods for the new suburban developments; as a result, they came into contact with non-Swedes. New friendships were formed and intermarriages increased, further weakening the old ethnic bonds. Many organizations were undermined by declining membership and passed from existence, while old neighborhood stores closed their doors, victims of larger competitors and a decline in the ethnic market. Today, the legacy of the Swedish American experience is still with us in the form of family and communal traditions, food, and a smaller yet still active organizational community. In certain circles, Swedish continues to be spoken. Throughout the region, religious and social buildings, cemeteries, and street names stand as reminders of the once flourishing ethnic community.

The Swedish American community has transformed itself over the course of the last century, but one constant remains: our heritage. The individuals in this book were our grandparents and parents, aunts and uncles, friends and neighbors. They were business and religious leaders, doctors, mechanics, bakers, farmers, and factory workers. Their life experiences were varied and their expectations different, yet these common individuals are the true representatives of what it meant and still means to be Swedish American. It is hoped that this new volume will provide the present descendants with a better understanding of their own past, present, and future.

One

FROM WHENCE THEY CAME

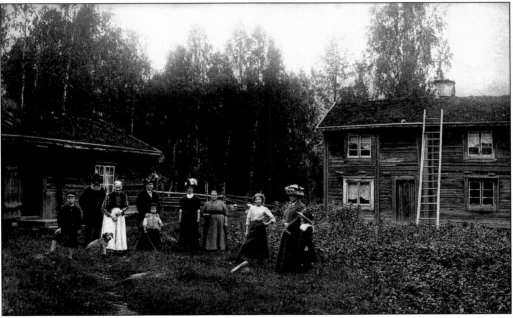

Sweden in the mid-19th century was a tradition-bound land of rigid protocol and manners. The religious life of the people was bound to the state Lutheran church, which allowed minimal dissent. During periods of famine, the people were reduced to eating a crude form of flour made from tree bark mixed with grain meal. Immigration was forbidden until 1840, while the military conscription of men was mandatory by the 1880s. Industrialization, although arriving late to Sweden, further aggravated the economic situation for many and led to crowded conditions in cities. By the beginning of the 20th century, the typical Swede lived in a house similar to that seen here. The Carl A. Carlson family emigrated from Västmanland province and settled in Worcester. Pictured in this 1912 postcard are relatives Per E. and Mora, together with Hilda Petterson, Hulda Ostlund, and her children. This card was simply addressed "Herr Carl A. Carlson, America."

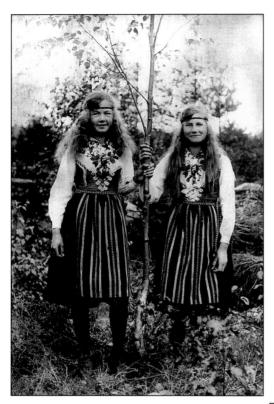

Folk costumes, birch, and the forested setting of Söderhamn highlight this portrait of the Nordquist sisters. The image dates from the second decade of the 20th century. National Romanticism, popular in Sweden during the last quarter of the 19th century, gave rise to the folk movement. During this period, many of the images now associated with Sweden were popularized: folk costumes, Midsummer and Lucia festivals, and the Viking mystique. Immigrants brought these new "traditions" with them to America.

The Åland Islands became a source of friction between Sweden and Finland until a 1920 decision by the League of Nations placed them under the dominion of Finland. The population is connected to Sweden by both language and heritage, however. As a result, Swedish customs are preserved. The most festive of these is Midsummer, which marks the longest day of the year. In this 1920s postcard, the traditional Maypole (*Midsommarstång* or *Majstång*) stands as testimony to this summer celebration.

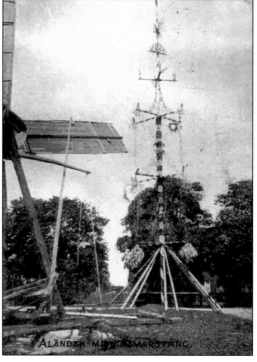

ALÄNDSK MIDSOMMARSTÅNG.

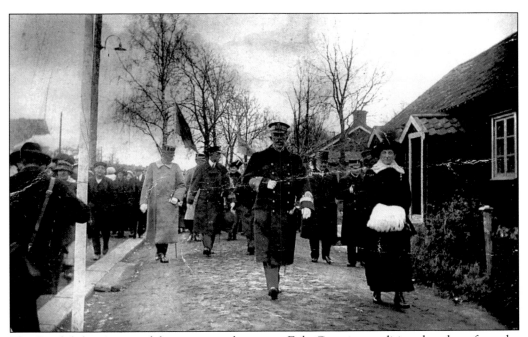

The Swedish king's tour of the provinces, known as *Eriks Gata*, is a tradition that dates from the Middle Ages. Standing well over six feet tall in the center of this photograph is King Gustav V, visiting a village in the province of Västergötland during his 1917 circuit.

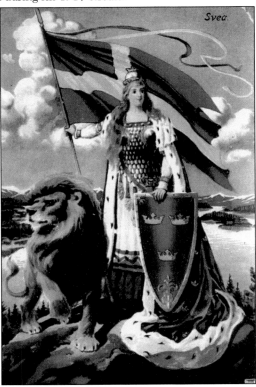

Nationalistic icons dominate this *c.* 1900 postcard from Sweden. Mother Svea, the nation's matriarch, holds both the Swedish flag and a shield embossed with the Three Crowns. The triple-crown motif was used as early as the 1300s and today graces both the Lesser and Greater Coat of Arms. The lion, a symbol of state, stands guard over his master while the Swedish countryside lies in the distance. The lion is found on Sweden's Greater Coat of Arms. Such symbolism was a powerful factor in the development of a national identity during the late 19th century.

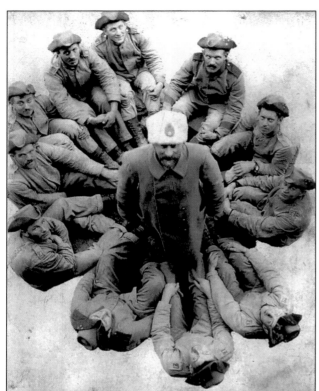

This novelty photograph features soldiers of the 27th Hälsingland Regiment of the Home Guard, or Carolinier, are shown in traditional headgear. This headdress honors a long tradition instituted during the reign of King Karl XII (1697–1718).

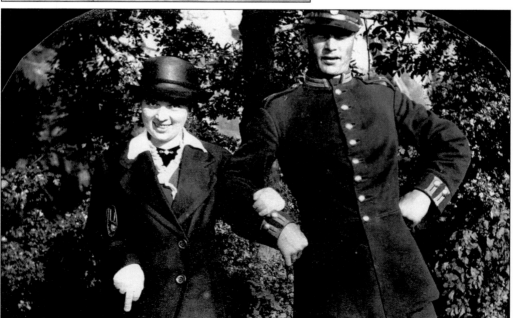

Although officially neutral in World War I, Sweden maintained a national defense system through universal military service. Posing proudly in his uniform is Volrath Mentzer with his wife, Thora. This 1918 photograph was taken in the Swedish town of Säffle.

May Day (Walpurgis Day) was originally a celebration of the spring season. Politics transformed the day into one associated with the labor movement and its achievements. Today, May 1 is the Swedish equivalent of Labor Day and is a national holiday. In this 1920s postcard, workers note the day by marching through an unnamed town in the province of Västmanland.

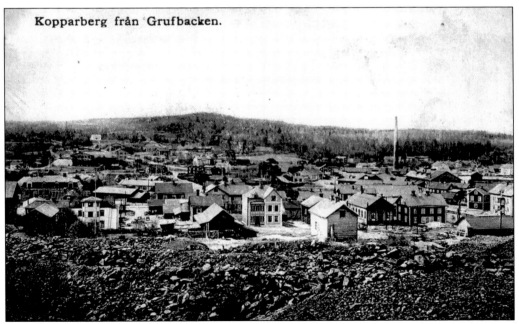

Kopparberg från Grufbacken.

The town of Kopparberg, in central Sweden, is pictured *c.* 1900. Situated in the heart of Västmanland province, the town derives its name from the abundance of copper, which was mined extensively in Sweden throughout the centuries. Many of the Worcester County Swedes hailed from this region.

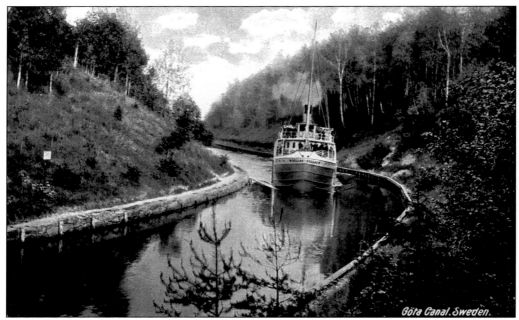

The Göta Canal, connecting Stockholm in the east to Göteborg in the west, was opened for traffic in 1830. The canal and its system of locks took 22 years to construct with a workforce of more than 58,000 men. In 1998, the canal was designated an International Historic Civil Engineering Landmark. In this 1920s postcard, a passenger vessel traverses the narrow canal through the quiet Swedish countryside.

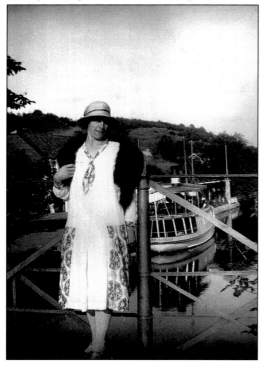

In this c. 1920 photograph, Elsa Ericson poses at one of the many scenic spots along the Göta Canal while a passenger boat passes in the background. The canal was constructed to help aid in the east–west transport of materials. Today, the original commercial status has been supplanted by its use as a popular tourist destination.

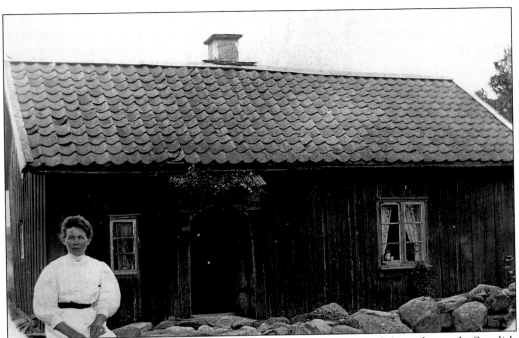

The population of the Åland Islands is predominantly ethnically Swedish, and as such, Swedish is spoken. Today, the islands remain a semiautonomous province complete with a national flag. In this 1914 photograph, Anna Johansson is pictured with her typical Åland *stuga*, or cottage.

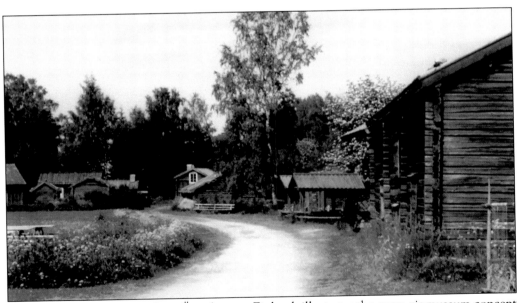

The Stundars Museum in Vora, Österbotten, Finland, illustrates the open-air museum concept prevalent in Scandinavia. Located throughout Finland and Sweden, these museums celebrate the once popular folk movement and include historic houses and structures that have been moved and placed amongst the grounds, creating a living village. The first of this type was Skansen, developed by Arthur Hazelius and opened in Stockholm in 1891.

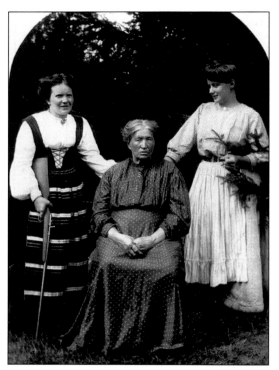

In this photograph of contrasts, anunidentified girl from the province of Dalarna poses in folk costume, complete with shotgun. Her grandmother (seated) and a companion complete this unusual image.

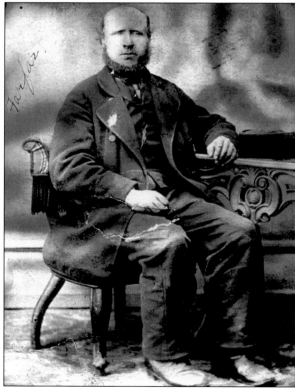

The rugged character of Johan Nordquist is evident in this c. 1870s photograph taken in the province of Hälsingland.

Alongside the old Göteborg city moat is a 28-acre private park and pleasure ground known as *Trädgårdsförening* (Garden Society). Within the park is an elaborate glass palm house and fine restaurant. In this 1928 photograph, Birgitta (right) and Rigmor Erikson are shown in front of the original restaurant. This Victorian-era building was destroyed by fire in the 1960s and was later rebuilt.

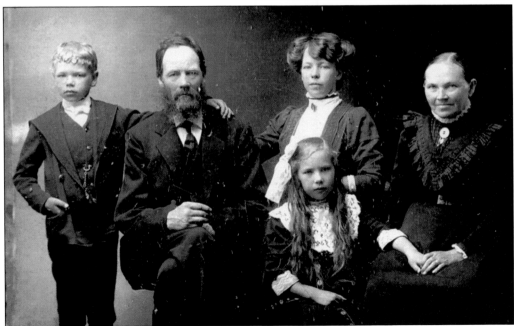

The Salomon family of Guldsmedshyttan, Västmanland, poses for a portrait c. 1909. From left to right are Hilmer, Jan Petter, Signe, Ingeborg, and Emma Maria. By the time of this photograph, two children—Carl and Hanna—had already journeyed to Massachusetts. Carl settled in Worcester, and Hanna married and moved to Quincy. In 1921, Hilmer reunited with his older brother in the city.

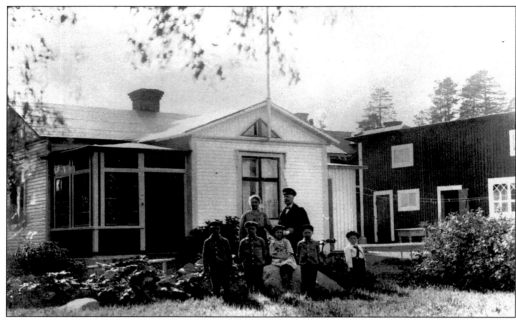

Relatively few of the region's Swedes made the lengthy journey from the northern province of Norbotten (bisected by the Arctic Circle). However, there were enough to warrant notice in the provincial newspaper *Norbottens Kurien*, which reported in 1887, "The Swedes of Worcester, Mass., have decided to request that the medical officer for Nederkalix, Sweden come over to them and settle down there as a doctor." This 1919 scene depicts the Nils Oskar Gustav Blomquist family in Luleå, with 5 of 11 children present. Two made the trip to America, with Gustav Odin arriving in Massachusetts in 1922.

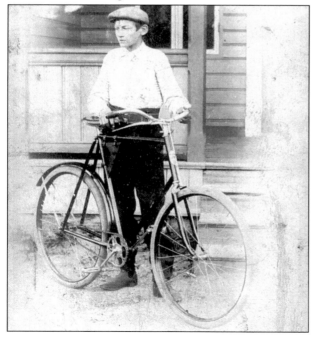

Klas Wiktor Jansson poses with his bicycle in 1898. In 1902, Jansson left his hometown of Kopparberg for Worcester, where he married Alma Matilda Lindegren and fathered two children. Shortly after his arrival, Jansson anglicized his name to C. Victor Johnson.

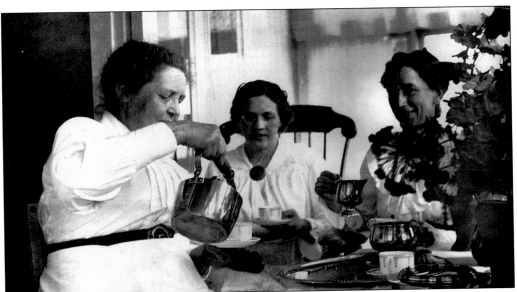

Coffee hour has always been an important part of the Swedish lifestyle. In this 1914 photograph, three friends enjoy *kaffee med dopp*, or coffee with a bit of sweets for dunking. Such gatherings allowed friends and family to catch up on local affairs—or to engage in a bit of friendly gossip. For the majority of Swedish immigrants, this tradition was preserved upon arrival in America. Also seen at the gathering is the ever-present coffee pot, the unofficial symbol of Swedish culture.

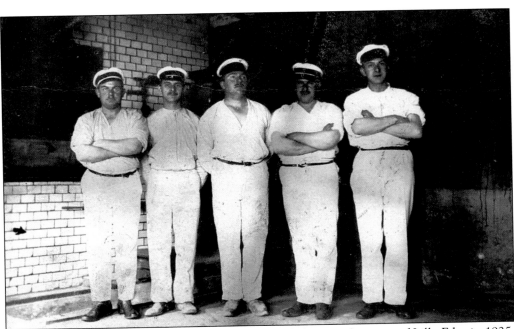

Knut Erikson (left) poses with the proud staff of his bakery in the town of Lilla Edet in 1925. Erikson immigrated to Worcester and subsequently sent for his family. A lifelong baker, Erikson worked for many years at the Swedish-run Quarfoth and Son Bakery on Trowbridge Circuit. The establishment eventually became known as the Scandinavian Bakery.

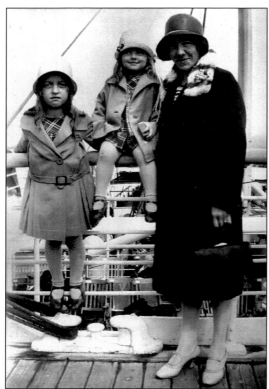

Birgitta (left), Rigmor (center), and Elsa Erikson are shown shortly after embarking from the Swedish port city of Göteborg in 1928. They booked passage on the Swedish American liner *Drottningholm* in order to join family patriarch Knut Erikson. He had arrived earlier in Worcester to establish a home for his expectant family.

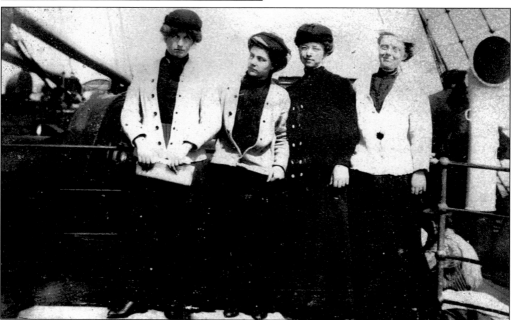

In 1902, sisters Alma and Helga Lindegren (first and second from left, respectively) emigrated from their home in Småland to join cousins in Worcester. This photograph captures the sisters with shipboard friends en route to America.

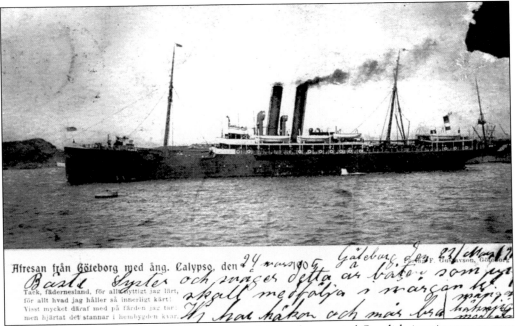

Afresan från Göteborg med ång. Calypso, den 24 mars 1905

Tack, fädernesland, för allt nyttigt jag lärt,
för allt hvad jag håller så innerligt kärt!
Visst mycket däraf med på färden jag tar;
men hjärtat det stannar i hembygden kvar.

The steamship *Calypso* was one of a myriad of ships that carried Swedish immigrants to new opportunities in North America. This postcard, written from the port city of Göteborg on March 24, 1905, reads, "This is the boat I will be leaving on tomorrow." In the lower left-hand corner is a sentimental poem in remembrance of Sweden.

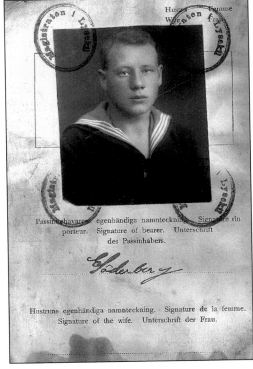

Passinnehavarens egenhändiga namnteckning. Signature du porteur. Signature of bearer. Unterschrift des Passinhabers.

Hustruns egenhändiga namnteckning. Signature de la femme. Signature of the wife. Unterschrift der Frau.

The passport was invaluable to the emigrating Swede. Long after its expiration, it became a treasured family keepsake. Shown here is the 1928 passport of Carl Erik Wilhelm Söderberg, issued in the coastal town of Lysekil in Bohuslän province. A member of the Swedish navy prior to his arrival in the Worcester area, Söderberg is pictured in his naval uniform.

$\mathcal{V}.$ 3.

Blankett till intyg enl.
§ 11 mom. 3 lagen om
skyddskoppympning.

Undertecknads jour-
nal över skyddskopp-
ympning år
nr

Intyg
över skyddskoppympning.

Karin Ingeborg Fransson *18* år från
(fullständigt namn) (ålder)

Munkfors
(kyrkskrivningsort)

(i fråga om minderåriga: föräldrars eller målsmans namn och bostad)

har av mig skyddskoppympats med { animalt / ~~humaniserat~~ } ympämne den *10*/*10* 19*23* .

Vid av *mig* den *19*/*10* 19*23*
(undertecknad eller särskild oesiktningsförrättare)

företagen besiktning har det visat sig, att skyddskoppympningen { ~~slagit an.~~ / icke slagit an.

........... *Munkfors* den *19*/*10* 19*23* .

B. Fredin
Leg . läkare.

This 1923 certificate served as proof that 18-year-old Karin Ingeborg Fransson of Munkfors, Värmland, was inoculated for smallpox prior to her departure to join family in Worcester. In addition to certificates of health, arriving immigrants were oftentimes required to undergo embarrassing medical inspections at ports of entry in North America. Failure to pass commonly resulted in quarantine or even deportation back to the country of origin. Following her arrival, Karin married Al Sjostedt and settled in Auburn.

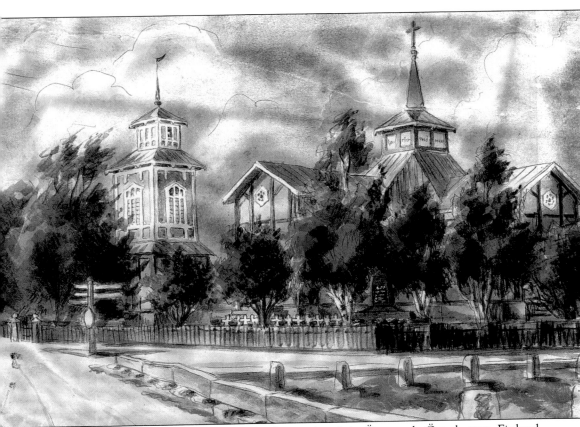

This watercolor is a fine rendition of the Lutheran church in Övermark, Österbotten, Finland, constructed in 1878. The small town of Övermark lies two miles north of Närpes and has a population of around 1,000, of which 98 percent are Swedish-speaking. Emigration affected this town considerably, and one 1940s account noted, "About 40 years ago the central village contained 125 people, of which only 4 families remained while the rest left for America." Many Swede-Finns throughout the county can trace their roots to this region in Finland.

23

ENDAST 19½ TIMMAR TILL STOCKHOLM

med nya

specialbyggda *DC-6* flygplan

Platsbeställning kan göras hos närmaste
auktoriserade resebyrå eller direkt från

SCANDINAVIAN AIRLINES SYSTEM

New York: RCA Building, West, Rockefeller Center, Circle 6-4000
Chicago: 37 South Wabash Avenue, RAandolph 6-6934
Minneapolis: 1110 Rand Tower, Lincoln 4735 and NEstor 6911
Los Angeles: 108 W. Sixth Street, TUcker 3739
Seattle: 824 White Building, SEneca 6250

passagerare - post - frakt

"Only 19½ Hours to Stockholm" pronounces this 1950 advertisement from the Scandinavian Airlines System. The post–World War II era saw the increasing popularity of jet travel. By the 1950s, Swedish immigrants could fly direct from Sweden to America, while air service made it possible for former Swedish subjects and their families to visit the homeland in a matter of hours. Today, the New York–Stockholm flight can be made in about eight hours.

Numerous Swedes settled throughout Worcester County long after the great period of immigration. One such "newcomer" was Lennart Söderman. Trained as a master baker, Söderman was lured to Worcester in 1969 after answering an advertisement placed in *Göteborgs Posten* by Crown Bakery. This 1967 photograph features Söderman as a naval member of Karlskrona Örlagsskolan, in compliance with Sweden's universal military service policy.

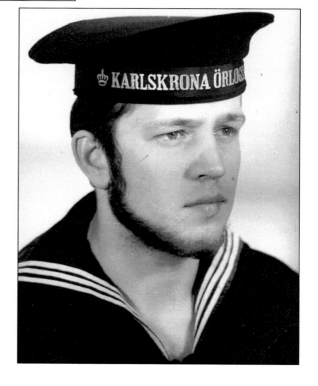

24

Two

HOME IN AMERICA

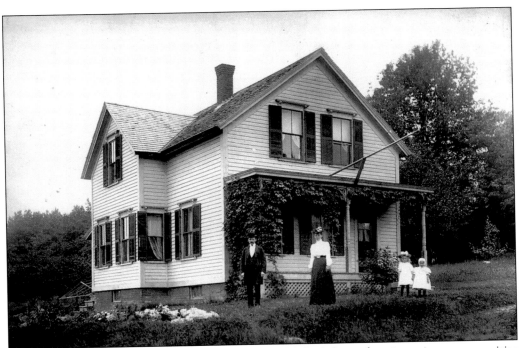

In time, Swedish immigrants and their families established themselves in various communities throughout the region. The network extended from Fitchburg and Gardner in the north to Millville in the south. In neighboring Woodstock and Thompson, Connecticut, small Swedish enclaves established their own associations. These communities, however, overlapped in religious, familial, and organizational ties. In time, American influences helped mold the immigrants into a community of *Swedish Americans*. In this *c.* 1900 photograph, the Johnson family poses outside their home on Boyce Court (now Alden Street) in Auburn. From left to right are Walfred, Mathilda, Olive, and Gladys. Far from crowded inner-city neighborhoods, a Swedish American community developed within the quiet section of Trowbridgeville (now Hadwen Park) at the Worcester-Auburn line.

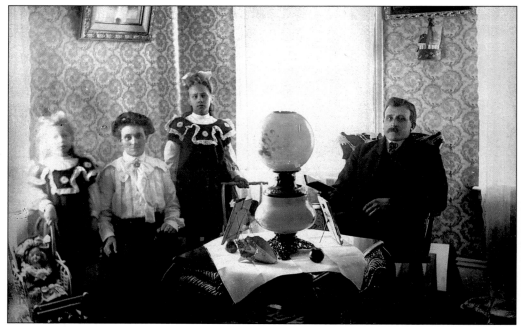

Life in Worcester seems to have agreed with the Löfgrens. As seen in this *c.* 1905 photograph taken at their Upsala Street home, the family enjoyed a comfortable standard of living. From left to right are Jenny, Anna, Ellen, and Jon.

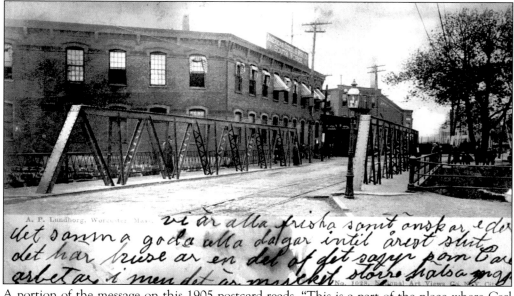

A portion of the message on this 1905 postcard reads, "This is a part of the place where Carl works but it is much larger than this." The American Steel and Wire Southworks plant in Quinsigamond Village, pictured here, was one of the larger employers of Swedes. By 1900, the largest concentration of Swedish Americans in Worcester County was within walking distance of this mill. The Southworks closed for good in 1971. Much of this complex was razed for redevelopment beginning in 2003.

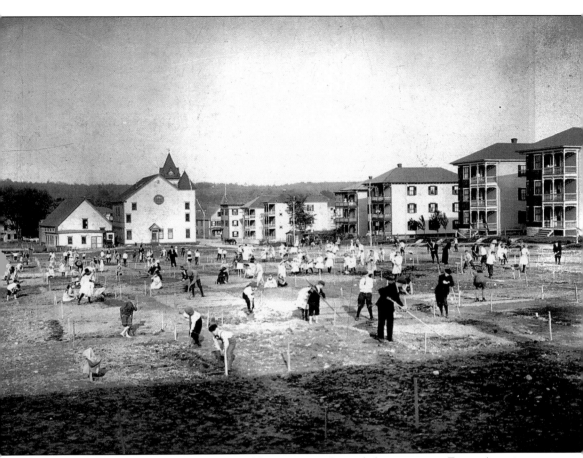

The entry of the United States into World War I transformed the economy. Every American was encouraged to conserve scarce materials and increase the production of foodstuffs. Food prices were monitored and government regulations established. Throughout the nation, Victory Gardens were planted in vacant lots and open land. In this remarkable 1917 photograph, Quinsigamond Village youngsters prepare garden plots for planting. In the background can be seen the Second Swedish Congregational Church (now Bethlehem Evangelical Covenant) and the three-deckers of Halmstad Street.

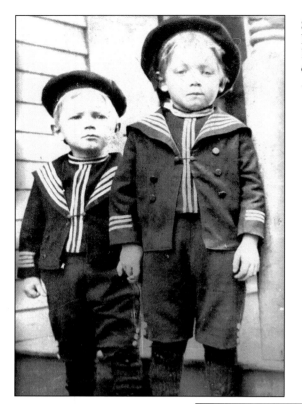

Sporting matching uniforms, brothers Ernest G. (left) and Carl E. Nordwell, looking ever so serious, pose on the steps of their Worcester home *c.* 1902.

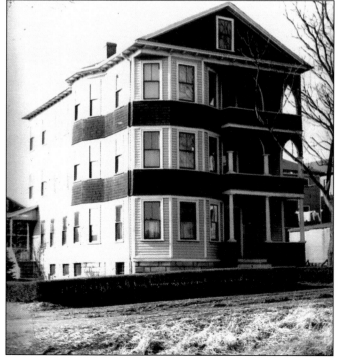

This three-decker at 6 Payson Street in Worcester was built in 1910 and for 40 years was home to the Nordwell family. Three-deckers were the preferred housing for many families, as costs could be divided. By 1930, several thousand had been constructed throughout the county. The well-maintained Nordwell home is seen here in a 1943 snapshot.

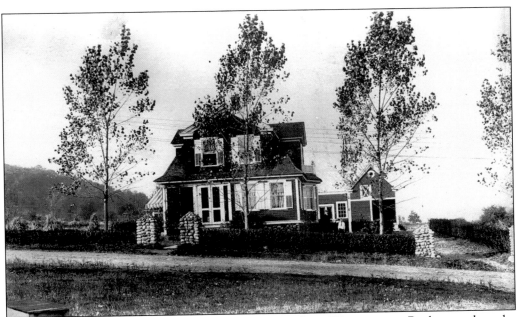

Anton Johnson moved his family from Belmont Hill in Worcester to Boylston, where he constructed this house on Glazier Street. The site soon became a welcome destination for city relatives, who rode the streetcar to "the country," where summer picnics and strawberry festivals awaited. For many Swedish Americans, a new home symbolized their arrival into the emerging middle class.

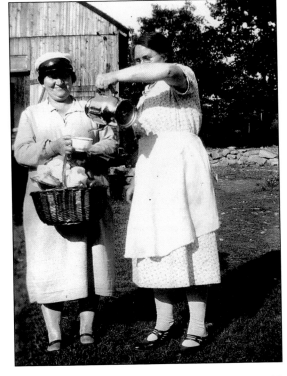

Visits to relatives and friends often highlighted the weekend's activities. At such gatherings, stories were shared, memories recalled, and bonds rekindled. For the region's Swedish Americans, no visit was complete without *kaffee med dopp*: coffee and some pastries for dunking. This photograph typifies such gatherings. Two friends share a laugh and refreshments at a Leicester Street homestead in Auburn *c.* 1930.

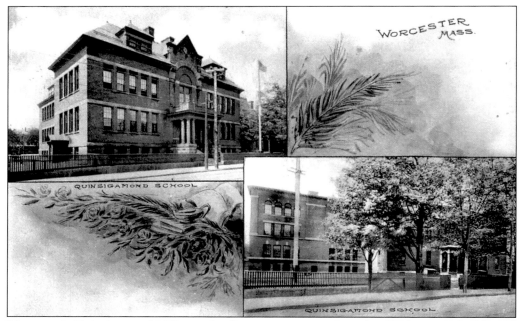

Worcester's Quinsigamond Village schoolhouses are pictured on this 1908 postcard addressed to Matilda Nilson of Farshaga, Sweden. The message on the back reads, "This is the school where Fridolf goes, so I am sending this card." Immigrant children were first introduced to the customs and standards of American society in the public schools. It was here that many also spoke their first words of English.

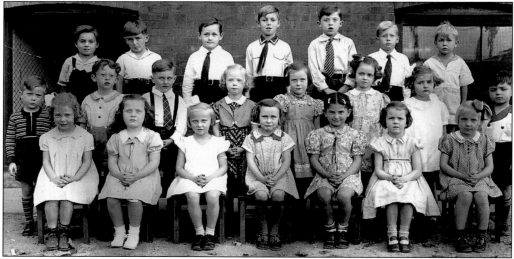

Many schools became ethnic centers, and Swedish Americans predominated at the Quinsigamond Village schoolhouses. The 1938 kindergarten class includes, from left to right, the following: (first row) Margaret Nordgren, Irene Gustafson, Harriet Forsberg, unidentified, Beverly Oleski, unidentified, and Alice Nordstrom; (second row) Walter Nordstrom, Francis McDermott, Richard Teague, Marion Thyberg, Betty Johnson, unidentified, Loraine Kropp, and Sam Carpinetti; (third row) unidentified, James Carroll, Richard Nylen, Lionel Lajoie, Richard Danielson, Richard Lindstrom, and Warren Nordstrom.

On a blustery winter's day in 1934, Rigmor Erikson skates along the Blackstone Canal in Millbury. Connecting Worcester with Providence, Rhode Island, the Blackstone Canal opened in 1828 and operated for a short 20 years before falling victim to the railroad. As illustrated here, the abandoned canal often became a recreational destination.

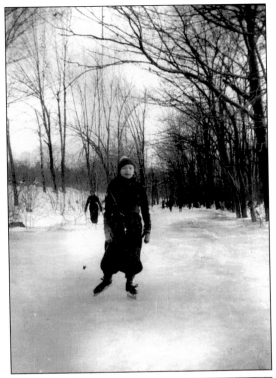

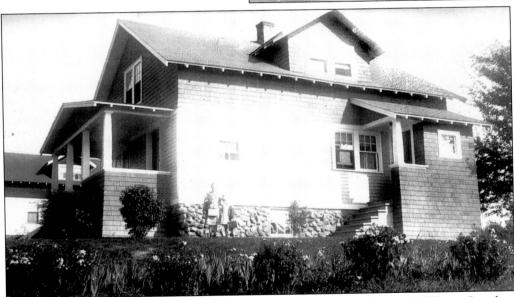

The Gullbergs were the first owners of this bungalow at 18 Johnson Street in Millbury. Standing outside their home for this 1936 photograph are sisters Lillyan (left) and Carolyn. Overall, Millbury had a smaller Swedish American population than its neighbors; however, a large contingent did settle around the shores of Ramshorn Pond. Here, they constructed summer cottages that were eventually converted into year-round residences. Today, many of these homes are owned by descendants of the original families.

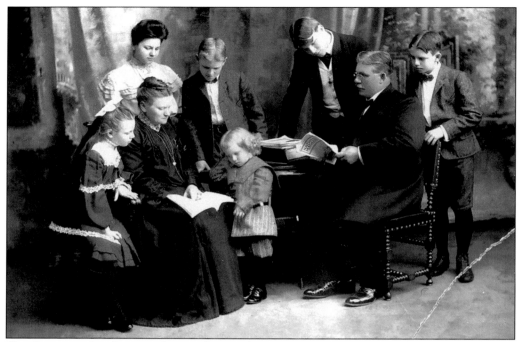

The Petterson family poses for a rather studious portrait in 1903. From left to right are the following: (first row) Ruth, Regina, Wallace, and Lars; (second row) Hulda, Harry, Elmer, and Oscar. Lars Petterson was a successful Worcester builder, and many of his sons eventually became contractors and businessmen in their own right.

Västmanland native Carl A. Carlson and his son Carl S. ready themselves for a boating excursion at adjacent Indian Lake in this c. 1920 photograph taken by their 49 Proctor Street home.

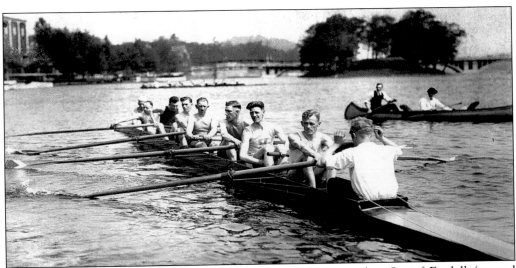

On a summer's day at Lake Quinsigamond c. 1925, crew member Gustaf Findell (second from right) readies himself as the coxswain shouts instructions. Watching from the canoe in the distance are his brother Frank (left) and friend J. Bergstedt. Two Swedish American organizations, the Engelbreckt Club and Svea Gille, established clubhouses along the shores of this popular recreational destination.

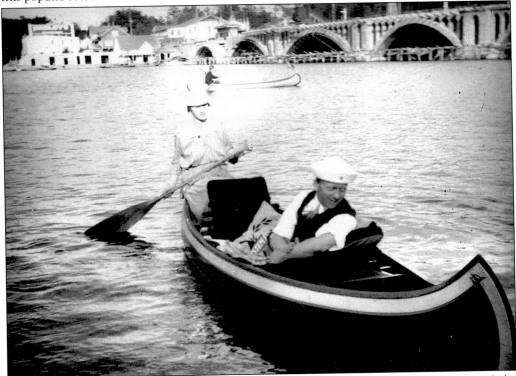

Gustaf A. Peterson lets Lillian M. Winberg do the rowing during an excursion to Lake Quinsigamond in the summer of 1919. The new Worcester-Shrewsbury bridge spanning the lake at Route 9 is under construction in the background.

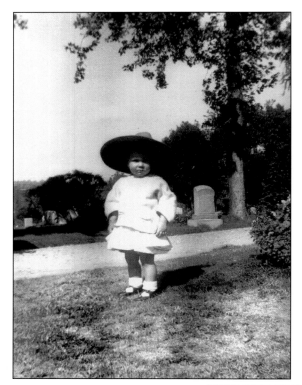

"These people have come to stay." More than a century has passed since these words were written by a *Worcester Telegram* reporter upon the 1886 dedication of the original Swedish Cemetery on Webster Street. During that time, generations of Swedish Americans have been interred at the two burial sites, now known as Old Swedish and All Faiths (formerly New Swedish) Cemeteries. This 1942 photograph shows little Betty Lou Skoglund at the grave of her grandparents John B. and Matilda Mard in Old Swedish Cemetery on Webster Street.

Ernest Lilyroot stands at the grave of his recently deceased wife, Emma, in this 1937 photograph taken amidst the open fields of New Swedish Cemetery. Although he had anglicized his name, Ernest still had the Swedish spelling of the family name, Liljeroth, inscribed on the memorial marker.

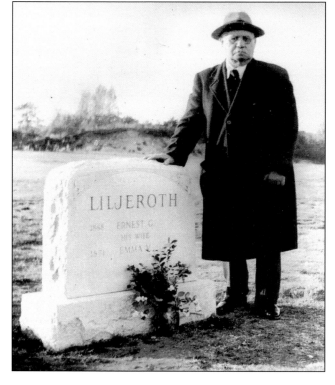

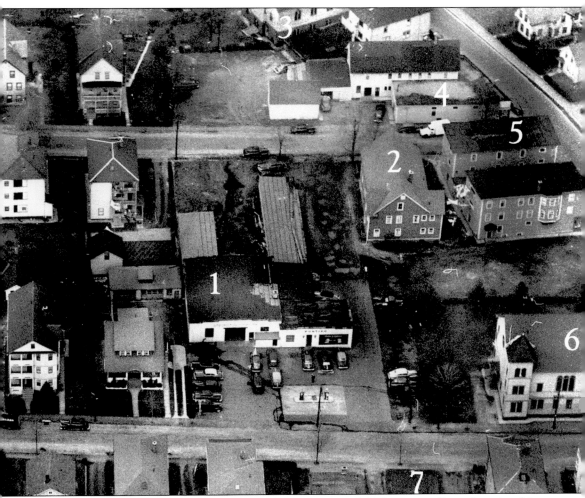

The dense Swedish American settlement of Quinsigamond Village is still evident in this c. 1947 photograph. The authors have labeled the following important landmarks: Stockhaus Motors (1); Quinsigamonds Väl, the International Order of Good Templars (IOGT) Hall (2); Emanuel Lutheran Church, originally Swedish Evangelical Lutheran Emanuel (3); Anderson and Sundquist Market (4); Quinsigamond Post No. 318 American Legion (5); Bethlehem Covenant Church, originally Second Swedish Congregational (6); and Quinsigamond Athletic Club (7). Halmstad Street is in the lower part of the photograph, and Ekman Street runs parallel above. To the right is Greenwood Street.

The John Ernest Johnson household, at 505 Burncoat Street, is pictured here in 1930. The Johnsons were but one of a host of Swedish American families who settled the Greendale section of Worcester, a community that developed around the Norton Company industrial complex.

... *Program* ...

för den gemensamma

Tacksägelsedagsgudstjensten

...af...

Worcesters Svenska Församlingar

...i...

SALEM SQUARE KYRKAN

1902.

Pastorerna

J. A. HULTMAN, E. J. NYSTRÖM, C. W. ANDERSON, C. A. CEDERBERG,
N. N. MORTEN, F. A. ENGSTRAND, F. O. LOGREN, LUDWIG AKESON,
JOHN GULLANS, KARL ARRY, J. A. MICHELS, CHRISTEN PETERSON.

Most immigrant groups soon adopted American holidays as part of their adjustment. In 1902, the Swedish congregations in Worcester observed a joint Thanksgiving service at the Salem Square Congregational Church. Twelve Swedish pastors, whose names are seen here, participated in the event. Although the event was held on an American holiday, it featured Swedish oratories and traditional Swedish hymns. Such ethnic celebrations fostered both a Swedish *and* American identity. Shown here is the program book cover from the event. The rather imposing term *Tacksägelsedagsgudstjensten* is translated as "Thanksgiving Day Service."

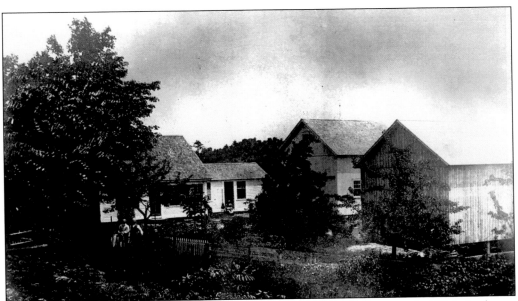

This 1901 photograph captures the Northside Road farm in Charlton, home to the Nils J. Anderson family. A Swede-Finn, Anderson emigrated from Östergötland, Finland, and in 1896 moved to Charlton from Hubbardston. He erected the new barn (right) in order to raise chickens.

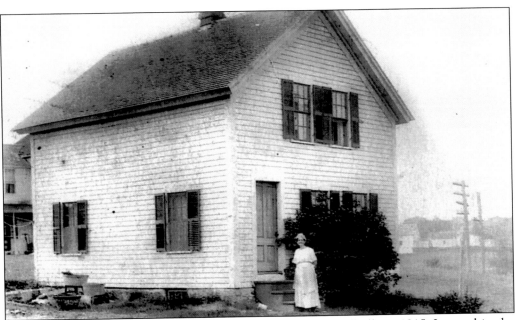

Petronella Hedin poses outside her Walnut Street home in Millville c. 1915. Located in the southwestern corner of Worcester County, Millville housed a small Swedish settlement. The local rubber company, U.S. Rubber, became the dominant employer of area Swedes. The Zion Evangelical Lutheran Church, complete with its own burial ground, served the spiritual needs of the ethnic community. The Great Depression affected the rubber plant deeply. As a result, many Swedes were forced to seek work elsewhere.

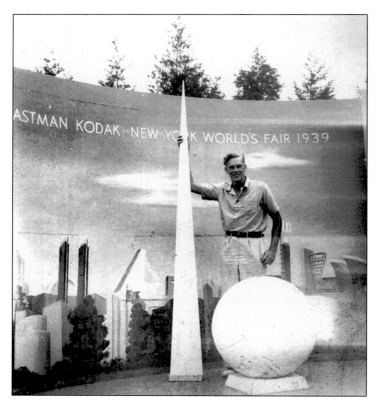

The 1939 New York World's Fair introduced thousands of Depression-weary visitors to the wonders of "the World of Tomorrow." One such enthusiastic fairgoer, Herbert Ringdahl of Worcester, poses here with the Trylon and Perisphere, symbols of the fair. The beloved Swedish Dala horse made its first American appearance at this popular exhibition and was quickly adopted by Swedish Americans as their own ethnic icon.

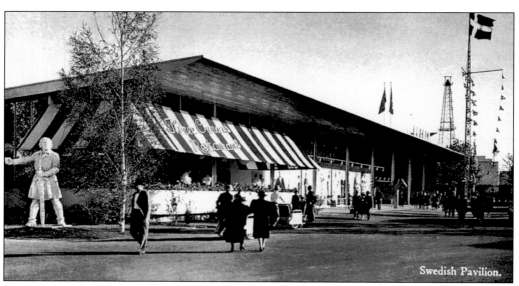

The fair's Swedish Pavilion featured the famous Three Crowns Restaurant. This eatery gave many Americans their first taste of Swedish cuisine. For Swedish American fairgoers, the delicacies were old favorites. Included on the menu were *räkor i majonnäs* (shrimp in mayonnaise) for 30¢ and *sillsallad* (herring salad) for 25¢. Aquavit was available for 40¢ or a bottle of Pripps beer for 5¢ less. The Swedish Pavilion won high praise from architectural critics for its elegant design.

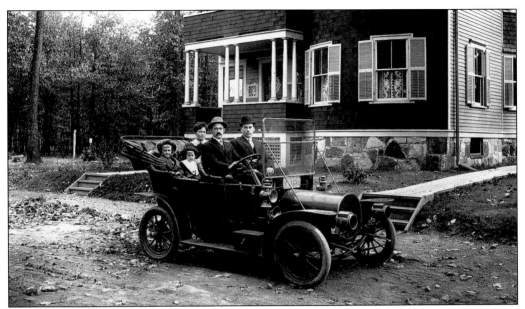

The Magnuson family and friends proudly pose outside the Magnusons' well-maintained Olga Avenue three-decker in 1915. Seated in the family's Franklin automobile are, from left to right, the following: (front) Charles Magnuson and Charles Hallstrom; (back) an unidentified Hallstrom child, Francis Magnuson, and his mother, Maria Catherine. Adjacent to this home was the entrance to the Scandinavian Salvation Army summer campgrounds.

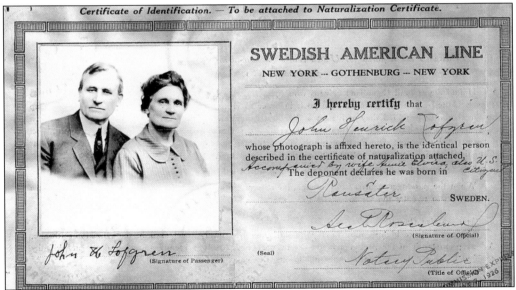

By 1920, transportation between Sweden and the United States had improved dramatically, with direct ocean service provided by the Swedish American Line. Voyages now took a matter of days rather than weeks. Such improvements enticed many to embark upon emotional return visits to Sweden. One couple who revisited the old country were John Henrick and Annie Elvira Lofgren, whose certificate of identification is shown here. This document was a necessity for former Swedish citizens making return trips to Sweden.

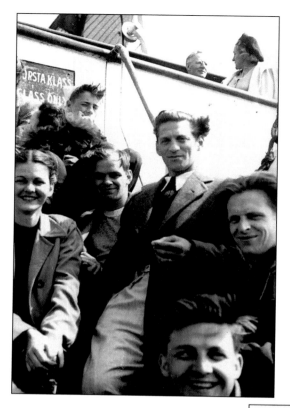

Rigmor Erikson fondly dubbed her 1947 return trip to Sweden "the Love Boat." In this coming-of-age photograph, Erikson (left) finds herself surrounded by smitten Danish and Swedish suitors aboard the Swedish American liner *Drottningholm*.

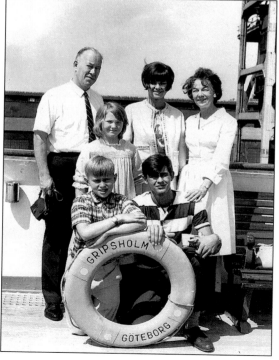

In June 1966, the Magnuson family took an extended vacation to Sweden aboard the liner *Gripsholm*. Francis (back left) and his sister Ellen (back right) pose with the youngest family members—Evelyn (back center), Karen, John, and David.

Three

PROFESSIONS, TRADES, AND SERVICES

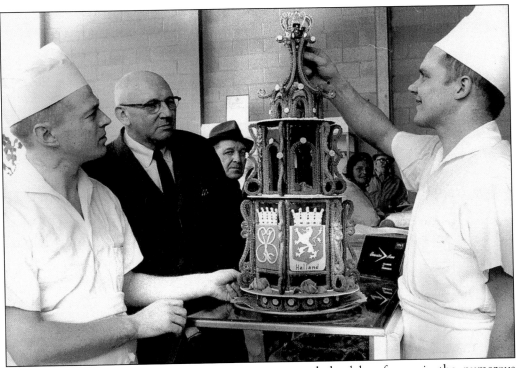

The vast majority of early Swedish Americans entered the labor force via the numerous industrial establishments located throughout the region. The Norton Company (in Worcester), the Iver Johnson complex (in Fitchburg), and the Grosvenor Dale Company (in North Grosvenor Dale, Connecticut) were prominent employers of Swedes. However, Swedes were both white- and blue-collar employees. Many became business owners, bakers, lawyers, politicians, and tradesmen; some were involved in agriculture. The workforce became as diverse as the community itself. In this 1963 photograph from the Crown Bakery, master pastry baker Lars Johansson (left) and president J. W. Benson (second from left) watch master baker Åke Lundstrom place the finishing touches on a *krokan*, a highly specialized Swedish pastry. The bakery, a Worcester-area staple since 1960, gained fame as a supplier of pastries and breads to the Swedish Pavilion during the 1964–1965 New York World's Fair.

41

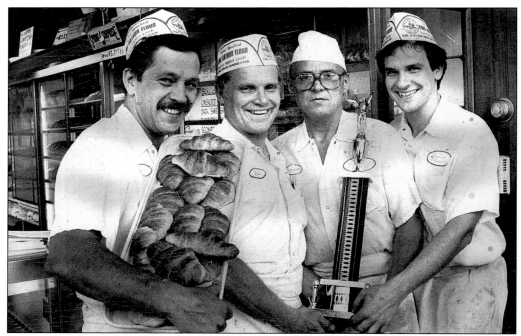

Among its many honors, Crown Bakery was awarded the grand prize at the Massachusetts Retail Bakers Association show in 1981. In this photograph, smiling proudly with their trophy and award-winning croissants are, from left to right, Swedish-born master bakers Lennart Söderman, Åke Lundstrom, Ingemar Grahn, and Jon Lundstrom. Åke Lundstrom became owner of the establishment in 1972. His son Jon now heads the business.

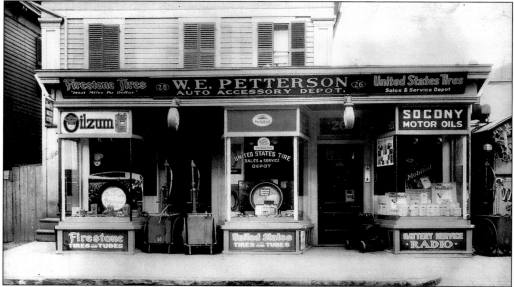

Wallace E. Petterson operated this automotive business on Grove Street in Worcester from 1925 until 1934, when it fell victim to the Great Depression. Following the auctioning off of this concern, Petterson became lead surveyor on the Quabbin Reservoir construction project and ended his career at the Norton Company.

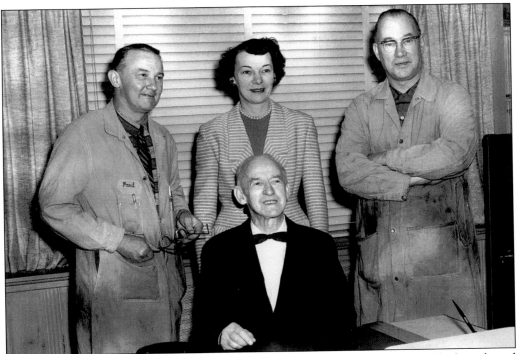

Charles Wilhelm Magnuson was born in Tutaryd, Småland, and trained as a blacksmith and machinist prior to his 1896 emigration. In 1900, he arrived in Worcester and employed himself in various positions such as toolmaker and designer. In 1913, he organized Worcester Tool and Stamping with John E. Jacobson, who soon left the firm. In 1949, the company left Worcester for new quarters in the Rochdale section of Leicester. In this 1959 photograph, Charles Magnuson (seated) is surrounded by his children, co-owners Paul, Ellen, and Francis.

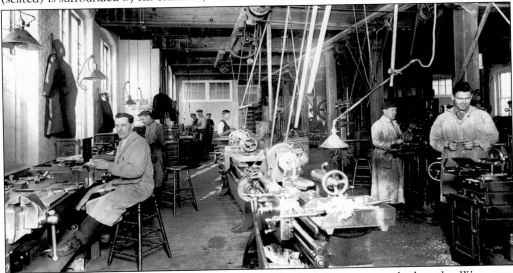

Prior to the establishment of his own concern, Charles Magnuson worked at the Worcester Metal Goods Company as plant superintendent. He is seated at his workspace on the left in this c. 1910 photograph.

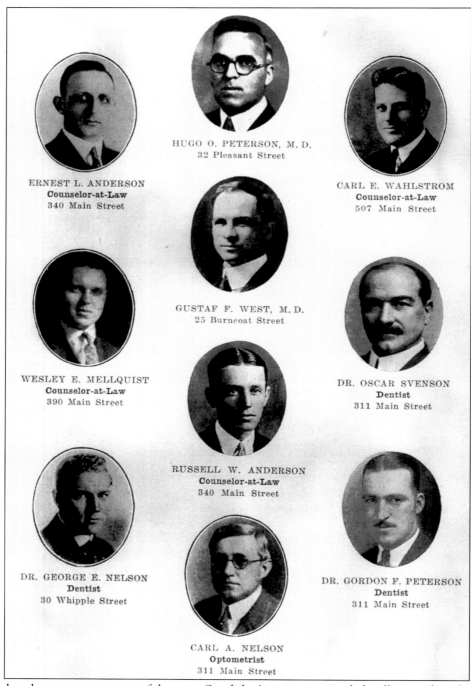

HUGO O. PETERSON, M. D.
32 Pleasant Street

ERNEST L. ANDERSON
Counselor-at-Law
340 Main Street

CARL E. WAHLSTROM
Counselor-at-Law
507 Main Street

GUSTAF F. WEST, M. D.
25 Burncoat Street

WESLEY E. MELLQUIST
Counselor-at-Law
390 Main Street

DR. OSCAR SVENSON
Dentist
311 Main Street

RUSSELL W. ANDERSON
Counselor-at-Law
340 Main Street

DR. GEORGE E. NELSON
Dentist
30 Whipple Street

DR. GORDON F. PETERSON
Dentist
311 Main Street

CARL A. NELSON
Optometrist
311 Main Street

As they became more successful, many Swedish Americans attended college and graduated with law or medical degrees. Seen in this 1927 collage are 10 such professionals popular in the Worcester area. Of these individuals, Carl E. Wahlstrom (top row, third from left) became a successful judge, while brothers Hugo O. (top row, second from left) and Gordon F. Peterson (bottom row, third from left) enjoyed long and distinguished careers of their own.

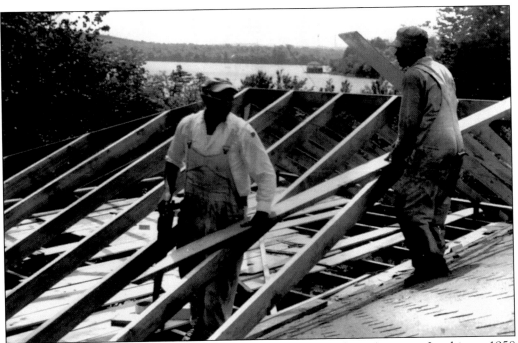

Many Swedes entered the building trade upon their arrival in America. In this *c.* 1958 photograph, lifelong carpenters Edward Hellstrom (left) and Hilmer Solomon are hard at work on an addition in Holden.

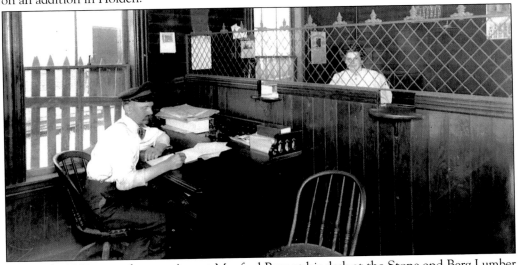

This early-1890s view features August Manfred Berg at his desk at the Stone and Berg Lumber Company office at 181 Union Street in Worcester. At this time, the concern shared space with another Swedish American business, the Hedlund Coal Company. The Berg Lumber Company was established in 1883; by 1891, it had bought two of its rivals—the Gates Lumber Company and the Stone and Foster Lumber Company—and moved to its present site at Heard and Stafford Streets. The business suffered a major fire in 1947 and, in 1999, removed itself from the retail lumber trade. This family-operated concern now deals in commercial hardware, safes, and building security devices.

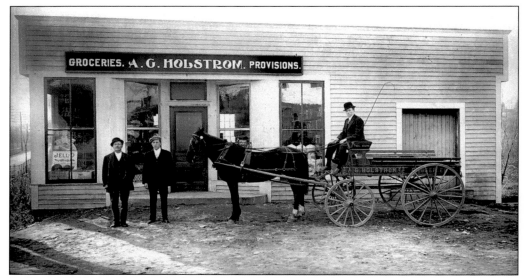

In this c. 1920 photograph, Andrew (left), Fritz (center), and Hjalmar Holstrom pose in front of their new market building at Drury Square in Auburn. Located on the corner of Auburn and Southbridge Streets, this structure replaced the original store on the opposite side of the square. Andrew Holstrom began his business in 1907. The concern quickly became popular with shoppers in Auburn and beyond for its delivery service. In 2004, the landmark building was demolished to provide space for the town's high school expansion project.

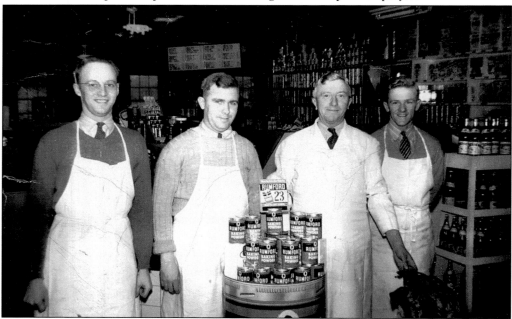

In this 1941 photograph, clerk Louis Breault (left) poses with Holstrom family members Floyd, Fritz, and Chester. The men are standing in front of a Rumford Baking Powder display. This popular brand of powder was at one time produced in another Swedish enclave, neighboring Rumford, Rhode Island. Stiff competition from grocery chains led to the closing of Holstrom's Market in 1966.

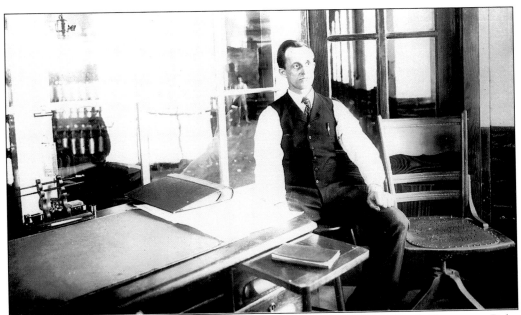

Carl E. Anderson was employed at the Grosvenor Dale Company in North Grosvenor Dale, Connecticut, for a record 59 years. Upon his retirement in May 1941, company officials honored him with a large farewell banquet at the Publick House in Sturbridge. This 1911 photograph shows Anderson in the card room of the cotton mill complex, where he was foreman. Many of the local Swedes found ready employment here.

Hjalmar Person was a quarryman and stonecutter in Concord, New Hampshire, when he decided to establish a monument works in Worcester. Following his death in 1928, his three sons—Everett, Harry, and Roy—assumed operations. Originally located on Fremont Street, Person Monument moved to Webster Street, adjacent to Old Swedish Cemetery. In 1985, the business was sold to Rex Monuments. In this 1968 photograph, skilled stone engraver Harry Person works on a grave marker.

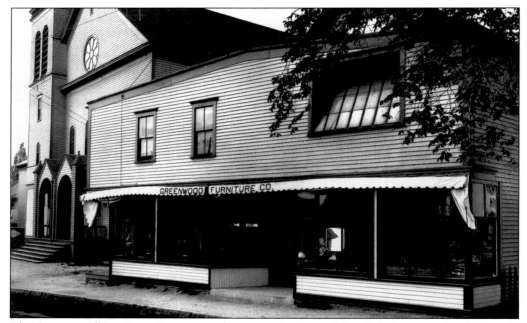

The Greenwood Furniture Company, adjacent to the Second Swedish Congregational Church, is pictured in this 1910 scene of Quinsigamond Village. In addition to this establishment, Swedish-born Wilhelm Forsberg owned a concrete company and a dry goods store. Forsberg was also involved in city politics and was the longtime president of the Swedish Cemetery Corporation. His influence was such that he was unofficially known as "the Mayor of Quinsigamond Village."

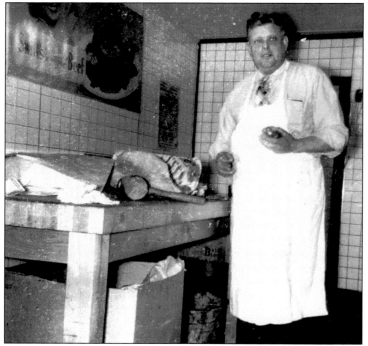

Following World War II, Otto and Pauline Hultgren purchased and enlarged a small general store on Main Street in Sterling. The business, called the Beef Shop, became known for its high-quality meats. In this 1947 photograph, Otto Hultgren poses behind the meat counter of his establishment.

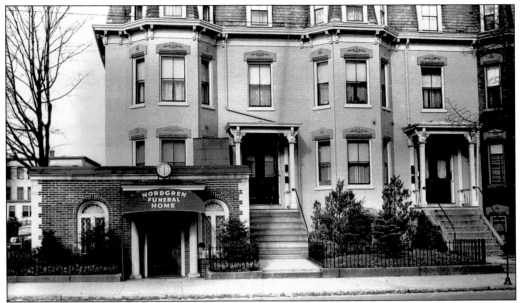

Carl E. R. Nordgren, a Stockholm native, established his undertaking business in 1912 after the purchase of the Benjamin Bernstrom Funeral Parlor. Nordgren's business, at 49 Belmont Street, next to the First Lutheran Church, is shown in this 1930 view. The business and the surrounding brownstones were demolished due to the construction of Interstate 290 in the 1950s.

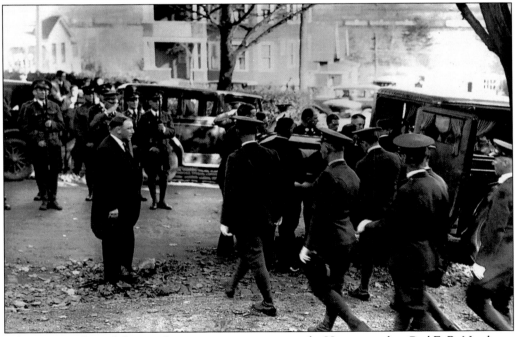

Oftentimes, a funeral director becomes a witness to tragedy. Here, a somber Carl E. R. Nordgren (left) watches as the flag-draped casket of Worcester firefighter Carl Swenson is attended to. In October 1929, two firefighters were killed and 11 injured fighting a large factory fire on Eden Street. Swenson was killed when a portion of the building collapsed upon him.

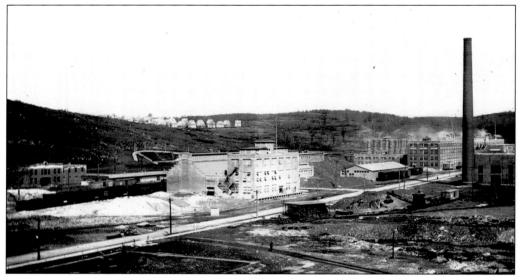

A portion of the Norton Company complex in Greendale appears in this *c.* 1916 view. In the distance stands the new workers' housing erected by the company. These new houses made up the Indian Hill Village community, an example of corporate paternalism that attracted national attention at the time of its construction. The Norton Company became the chief Swedish American employer and the prime motivator for the Swedish settlement in north Worcester.

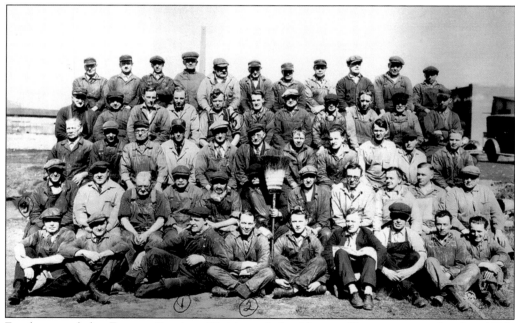

Employees of the Factory Services Division of the Norton Company pose for this 1920s photograph on company grounds. Identified workers include Knut Kullenberg and John Sundquist (first row, third and fourth from left, respectively), a Mr. Thernstrom (second row, left), and Oscar Erlandson (fourth row, fifth from left). At one time, more than half of the Norton workforce consisted of Swedish Americans.

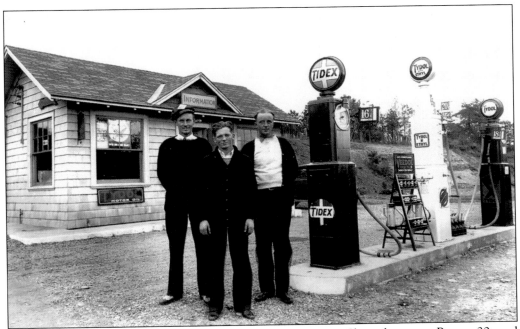

This c. 1935 scene shows the Tydol gasoline station in Shrewsbury, at Route 20 and Edgemere Boulevard. The smiling staff includes Ivar Ljunggren (left), Carl Johnson (center), and Axel Ljunggren. The Edgemere section of Shrewsbury housed a small community of Swedish Americans.

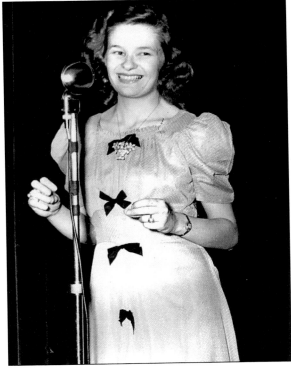

Carolyn Gullberg, age 18, is all smiles in this 1948 photograph taken at the Moors nightclub in Shrewsbury, where she won first prize in a singing contest. Gullberg began her career in 1945 singing on local radio stations WTAG and WAAB. She appeared with area bands throughout the region and was featured on bandleader Horace Heidt's radio program.

The Fitchburg Scandinavian population established its own network of business concerns. The following were among those listed in the 1920 Fitchburg city directory: George Lonnqvist and Hjalmar Wuori, painters; Laurits M. Neilson, manager of a Willow Street manufacturing concern; and Fred A. and J. Alfred Anderson, attorneys with offices in Fitchburg and Boston. The Scandinavian element in Fitchburg was made up largely of Finnish Americans.

Norwegian-born Iver Johnson and Martin Bye established an arms plant in Worcester in 1871. In the 1880s, Johnson bought out his partner and expanded his business to include the manufacture of bicycles. In 1892, he moved his company to Fitchburg, where his family ran the firm following his death in 1895. It soon became the largest producer of small firearms and shotguns in the nation. The company then expanded into the production of motorcycles. One 1930 account noted, "Every sixty seconds it turns out three revolvers; every two minutes it fabricates a shotgun, and every four minutes it manufactures a bicycle." Shown here is a 1912 article illustrating the Iver Johnson line of products.

Värmland native Benjamin Bernstrom settled in Worcester in April 1886 and began working with the construction firm Norcross Brothers. In November 1888, he established an undertaking business on Thomas Street. It was purchased by Carl Nordgren in 1912. Bernstrom was also a justice of the peace.

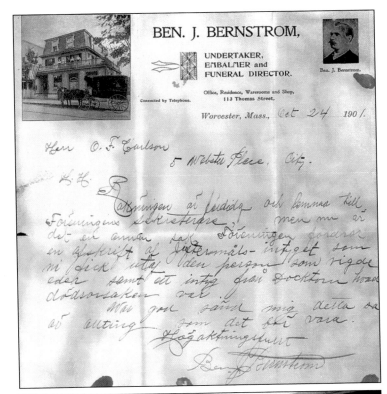

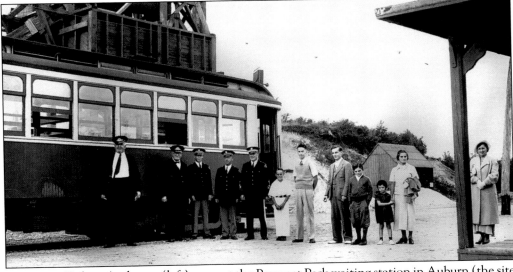

Motorman Robert Anderson (left) poses at the Prospect Park waiting station in Auburn (the site of the present St. Joseph's Church) on Sunday, September 1, 1935. Anderson piloted the first streetcar on the Webster and Dudley Street Railway in 1898. According to railway employee Wendell R. Nygren, a streetcar motorman had to be motivated, but "instead of standing at a lathe or loom for eight hours, one had an opportunity to meet people and see the city." These passengers likely await their last trolley ride, as the dependable electric cars made their final runs on that line the next day.

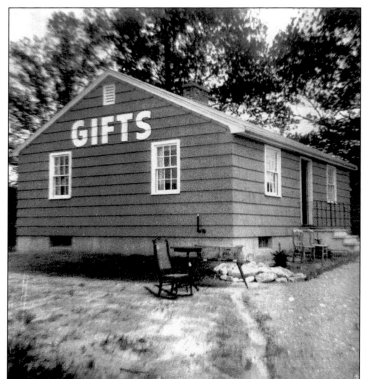

Marion and Gordon "Gub" Forsberg operated the Brass and Copper Shop on Route 20 in Auburn during the 1950s and 1960s. Depicted in this early image, the business offered Scandinavian imports and antiques in a general store setting. The Forsbergs now operate Scandia Specialties, a Scandinavian wholesale company that sells to retailers nationwide.

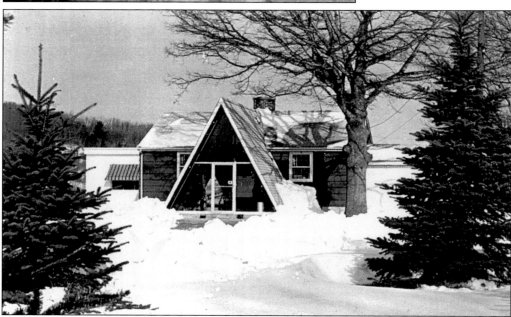

In 1976, Susan (Forsberg) Wilkicki reopened her parents' store as the Gift Chalet, the county's chief retailer of Scandinavian imports and food items. The business has expanded over the years and now carries a large selection of crafts, including the Cat's Meow series. This postcard features the store at the time of its opening, with its landmark A-frame entrance.

Andrew Holmstrom, Worcester's popular mayor (1950–1954), presents the ceremonial key to the city to visiting Swedish dignitaries Olof Hammar of Dalarna, Sweden (left), and Dr. Gustaf Hammar of Rochester, New York, in this 1950 photograph taken at city hall. Olof Hammar was a member of Sweden's *Riksdag*, or parliament.

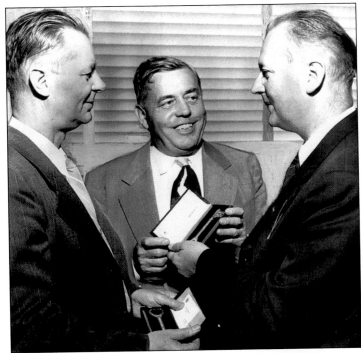

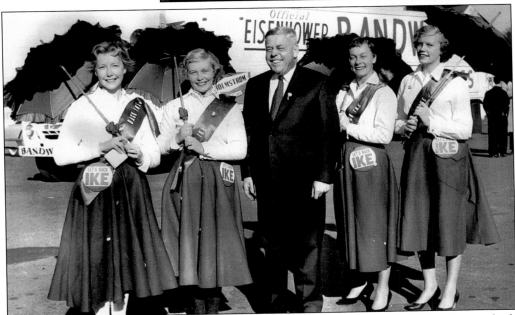

Politics were a family affair for the Holmstroms during the 1954 midterm elections, in which Andrew Holmstrom campaigned for Congress. Here, Andrew is surrounded by his ardent supporters and daughters Barbara Adams, Nancy Oakes, Joan Holmstrom, and Carol Holmstrom. Although he lost the election, Andrew continued to serve Worcester as vice mayor from 1954 to 1962; in 1967, he ended his 17-year tenure as city councilman. Holmstrom was also a longtime president of the Worcester Swedish Charitable Association.

Skåne native Peter Alfred Bengtson established his successful hardware business in Gardner c. 1910. A skilled woodworker, Bengtson was also an embalmer and operated a funeral parlor. This February 1936 advertisement from *Svea* notes that the store offered "the biggest value for the dollar" with quality that was "always the best."

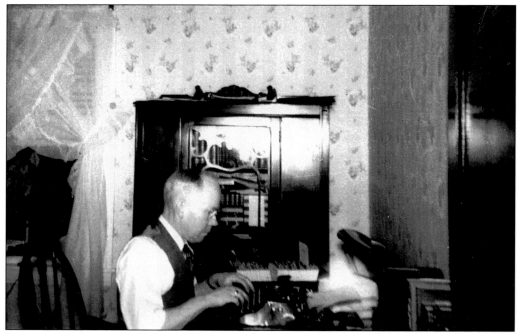

In his free time, Bror J. V. Rosenlund wrote for the Worcester Swedish American newspaper *Svea* and its successor, *Nordstjernan-Svea* of Brooklyn. His column, *Uncle Joe's Corner*, kept readers entertained and informed until his death in 1983. Perhaps Rosenlund is putting the finishing touches on one such article in this *c*. 1945 photograph taken at his Ekman Street home in Worcester.

Anton Trulson, pictured here in the 1940s, assumed management of the Svea Publishing Company after the death of his father, Hans, in March 1908. Anton and his brother Harold operated the concern until the company was sold to the Swedish News of New York. The newspaper *Svea* was subsequently merged with *Nordstjernan*.

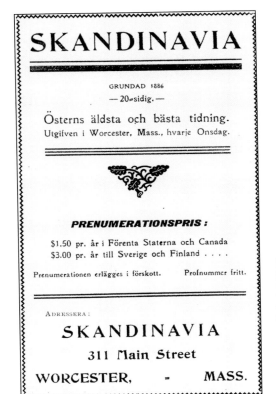

One of the most successful of the early Swedish American newspapers in the New England region was *Skandinavia*, distributed by the Swedish Publishing Company of Worcester. Established in 1886, *Skandinavia* was bought by the Svea Press of Worcester in 1918 and absorbed by the rival *Svea*. In this 1904 advertisement, the 20-page publication is advertised as "the East's oldest and best newspaper."

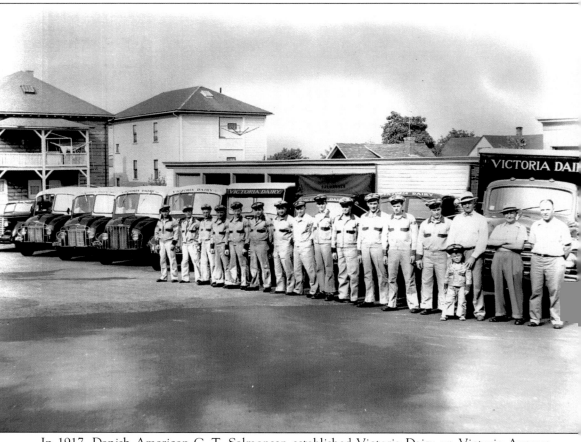

In 1917, Danish American C. T. Salmonsen established Victoria Dairy on Victoria Avenue in Worcester's Quinsigamond Village. The dairy was one of the more popular Scandinavian American milk dealers that operated out of Quinsigamond Village. Salmonsen's was the last remaining dairy in the village when it closed in 1979, marking the end of an era. Employees pose with the company's fleet of trucks in this 1947 photograph. Identified are Paul Wennerstrand (7th from left), Bob and Larry Salmonsen Jr. (12th and 13th from left, respectively), Larry Salmonsen Sr. (14th from left), and Eric Scott (16th from left). Gary Salmonsen, the young fledgling driver in front, appears ready and willing to work.

Four

THE FAITH EXPERIENCE

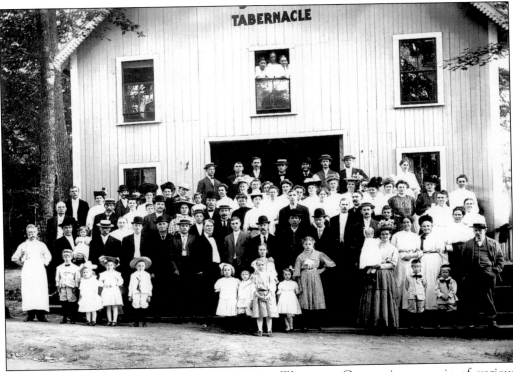

The Swedish American religious experience in Worcester County is a mosaic of various Protestant denominations. Most numerous are the Lutherans; however, large numbers of Methodists, Baptists, and Congregationalists can be found throughout the region as well. For generations, the church was the center of life. Seen as the great defenders of faith, these bastions of ethnic pride were among the first institutions to mainstream and now support the new fledgling immigrant groups in Worcester County. For several years, Worcester County Methodists met at the Sterling Junction Camp Grounds for church picnics and religious meetings during summer months. In this *c.* 1904 photograph, area Swedish Methodists pose in front of the Swedish Tabernacle, erected on the grounds.

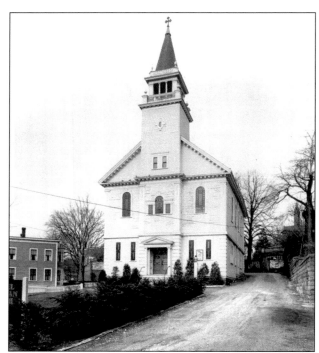

The Scandinavian Lutheran Society of Fitchburg was formed in 1888. When the Iver Johnson Arms and Cycle Works relocated to Fitchburg in 1892, the city, and thus the society, experienced an influx of Swedes. On May 26, 1892, the society became the Swedish Evangelical Emanuel Lutheran congregation. Construction on the church building began in 1896 and took five years to complete. An educational wing was built in 1952. This *c.* 1925 photograph shows the original edifice on Caldwell Place. In 1974, the Emanuel Lutheran congregation moved to its current quarters on John Fitch Highway.

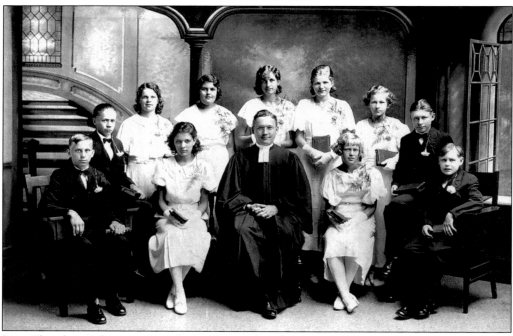

Rev. Theodore Palmer poses with the Emanuel Lutheran confirmation class of 1933. Pictured here are, from left to right, the following: (first row) Paul Siren, Lois Carrion, Rachel Mattson, and Walter Carlson; (second row) Einar Stolhandske, Helen Anderson, Ruth Sjoberg, Edith Ostman, Linnea Westine, Gerda Johnson, and Lester Carlson. Palmer served the Fitchburg congregation for six years, beginning in 1932.

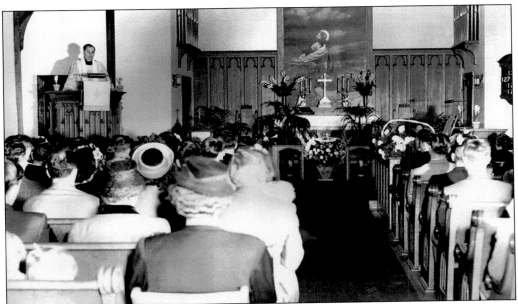

One of the more active pastors of the Emanuel Lutheran Church in Fitchburg was Rev. Hilmer Allison Linné (1943–1949). Under his tutelage, the church was updated and a parsonage purchased. Linné then served as the first pastor of Mount Olivet Lutheran in Shrewsbury. In this *c.* 1945 photograph, Linné delivers a sermon as the Fitchburg congregation listens intently.

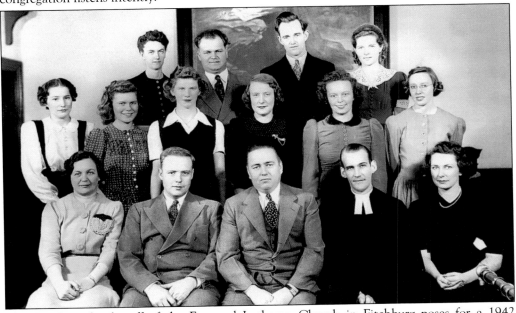

The Sunday school staff of the Emanuel Lutheran Church in Fitchburg poses for a 1942 photograph. From left to right are the following: (first row) Mildred Johnson, Robert Berg, Gustaf Gilberg, Rev. Fred Benson, and Mrs. Benson; (second row) Mrs. Robert Berg, Violet Linne, Edith Westine, Grace Seelig, Inez Stewart, and Olive Stewart; (third row) Catherine Rogers, Ingvald Johnson, Ainar Person, and Virginia Erickson.

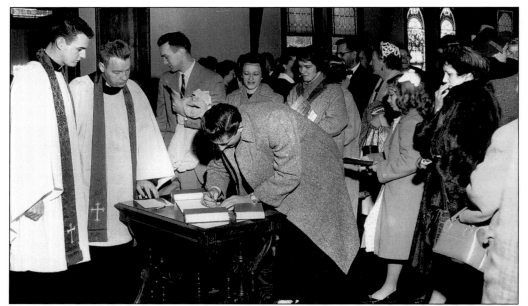

The 1950s saw a nationwide exodus to the suburbs, and local Swedish Americans were no exception. There, they settled into ethnically diverse neighborhoods. Christ Lutheran in West Boylston is one of the multiethnic "second-generation" Lutheran congregations formed in the post–World War II era. Many Swedish Americans were counted as its charter members. In 1957, organizational meetings began, and the first worship service took place in September 1958. On November 30, seventy-six people signed the charter at the Baptist church in West Boylston Center. In this photograph, Pastor Carl O. Ebb (left) watches as congregants affix their names to the charter.

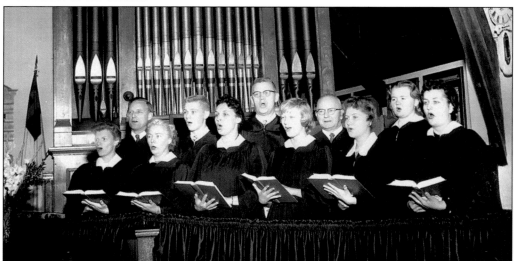

Prior to the construction of their own edifice, members of the Christ Lutheran congregation worshiped at the Baptist church in West Boylston Center. The 1959 choir includes, from left to right, the following: (first row) Lily Kastberg, Anna Peterson, Ruth Benson, Louise Lagerstrom, Jean Ebb, and Alice Ohristo; (second row) Al Kastberg, Philip Lagerstrom, Louis Lagerstrom, Phil Peterson, and Christine Johnson.

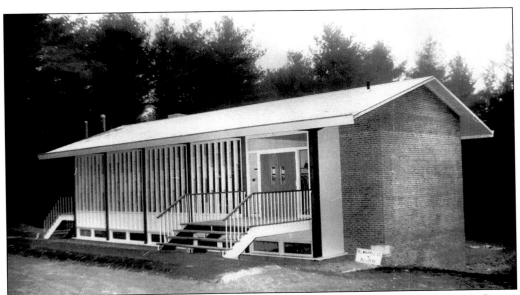

After more than a year of searching, a five-acre parcel of land was bought on Crescent Street, and on May 1, 1960, ground was broken for the Christ Lutheran Church building. Progress was swift, and on October 16, the first service was held. On November 13, the new church was dedicated. Shown here is the original unadorned edifice shortly after its completion. An addition in the late 1980s doubled the size of the church.

The first class confirmed in the new Christ Lutheran Church poses in this 1960 photograph with Pastor Carl O. Ebb (back center). The confirmed students are, from left to right, as follows: (first row) Ula Tobiesen, June Rindfliesch, and Martha Kastberg; (second row) Steven White, Donna Holm, Beverly Kastberg, and Donald Roselund.

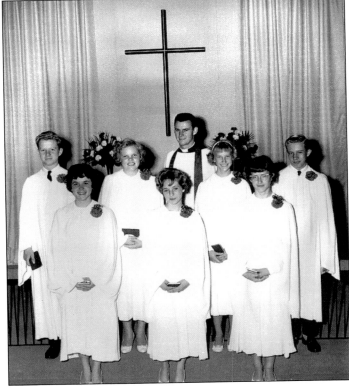

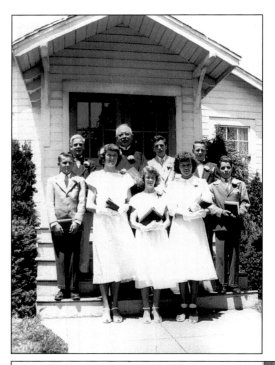

One of the last classes to be confirmed in the old Immanuel Lutheran chapel in Holden stands outside the building with Reverend Bostrom in 1948. From left to right are the following: (first row) William Smith, Jean Fournier, Nancy Carlson, Joan Jaques, and Richard Rindfleisch; (second row) Richard Johnson, Robert Keough, and Robert Rosenlund. In 1949, the current Immanuel Lutheran Church building was dedicated, replacing the 20-year-old wooden chapel.

Bilingual religious books were issued to Sunday school participants as a way to maintain the Swedish language. As seen here in the pages of this 1923 edition of *Bible Biographies*, each lesson was given in both Swedish and English. This particular book was loaned to Otto Hultgren by Rhoda Fales, both young members of the Scandinavian Evangelical Congregational Church, located at Chaffins in Holden.

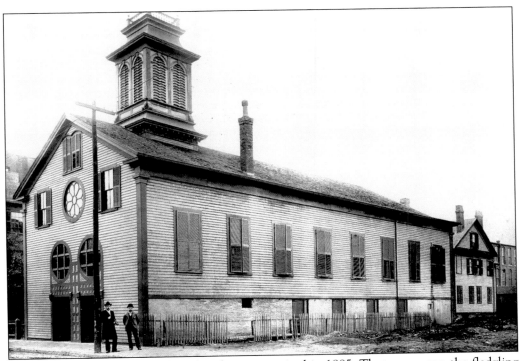

The Second Swedish Methodist Church was organized in 1885. That same year, the fledgling congregation purchased a church on Thomas Street at the intersection with Commercial Street. In 1899, the church was completely rebuilt to accommodate the widening of Commercial Street. Shown here c. 1890 is the original church building. The congregation moved to Salisbury Street upon the completion of the Epworth Swedish Methodist Church in the 1920s.

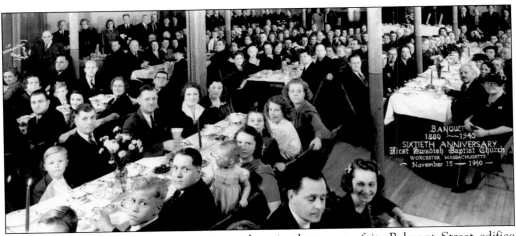

The First Swedish Baptist congregation gathers in the vestry of its Belmont Street edifice to commemorate its 60th anniversary in November 1940. There was much to celebrate; the church was one of the largest of the Swedish Baptist congregations in the east, and its members helped to establish five additional congregations: two in Worcester; one in Gardner; one in Cleveland, Ohio; and one in Wakegan, Illinois. The name of the congregation was changed to Belmont Street Baptist in 1942.

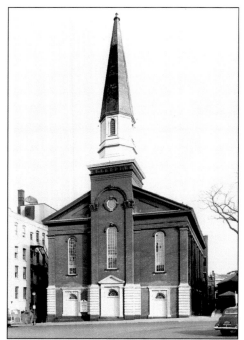

The First Swedish Congregational Church moved from its Providence Street location in 1896 after purchasing this edifice at Salem Square; it popularly became known as the Salem Square Congregational Church. The structure housed the congregation until 1969, when members moved into the new church on East Mountain Street. Construction of the Worcester Center Galleria necessitated the removal of this church. Shown here is the former Salem Square edifice c. 1945. In 1949, the congregation was renamed the Salem Square Covenant Church, reflecting its 1948 affiliation with the Covenant Church of America.

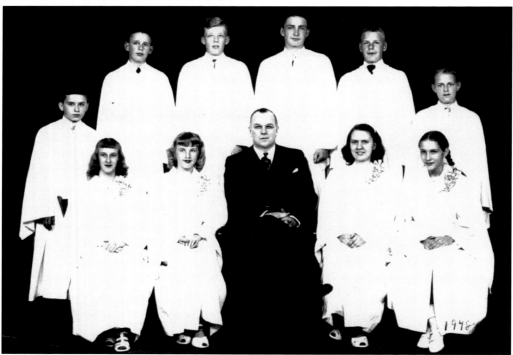

The Salem Square Congregational Church confirmation class of 1948 poses with Pastor Ostberg. From left to right are the following: (first row) Janet Nordgren, Carol Varg Logan, Nancy Ellison, and J. Wapula; (second row) Philip Becker, Kendall Nylin, two unidentified boys, Conrad Johnson, and W. Russell Anderson.

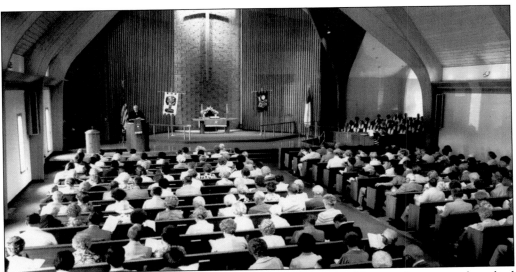

Pressures such as the decline of the downtown business district and future urban renewal resulted in the relocation of the Salem Square Covenant Church. In 1966, land was purchased on East Mountain Street, and groundbreaking ceremonies were held in October 1967. In February 1969, services began in the new church. The exceptional interior of the current church is shown in this June 22, 1980, photograph taken at the church's centennial celebration. On that day, congregants listened intently as Rev. Milton Englebretsen delivered his sermon.

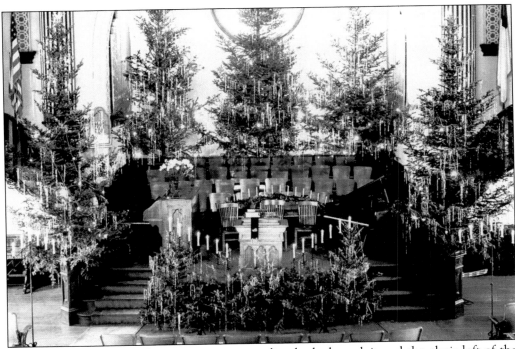

The lavishly decorated Christmas trees surrounding both the pulpit and the choir loft of the Bethlehem Evangelical Church (Bethlehem Covenant) on Christmas Day 1941 provided a small glimmer of light as the United States entered World War II.

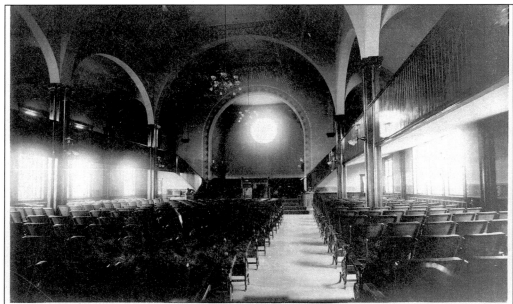

Kyrkans Interiör.

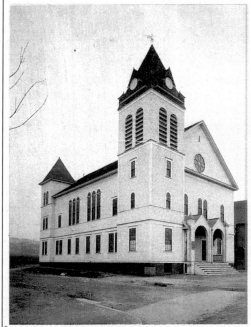

Andra Svenska Congr. Kyrkan.
Worcester, Mass.

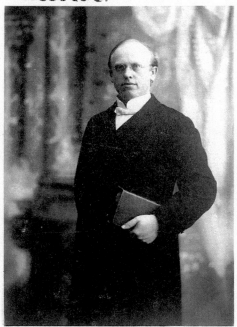

Ludwig Akeson,
pastor

These c. 1905 photographs show the exterior and interior of the Second Swedish Congregational Church (Bethlehem Covenant) and Rev. Ludwig Akeson, who served as pastor between 1901 and 1906. The studio of Albin Eklof in "Quinsigamond, Mass" produced this interesting triple-image montage.

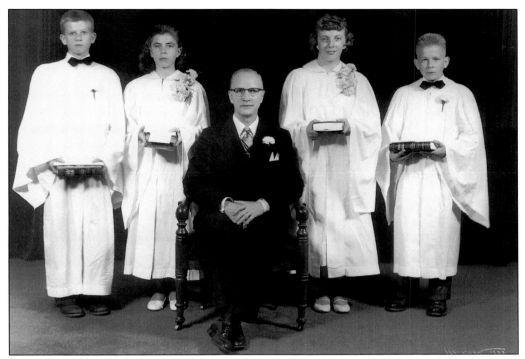

Rev. Virgil Wickman of the Bethlehem Covenant Church poses with the small confirmation class of 1953. The confirmants are, from left to right, Wallace Westerberg, Barbara Beeso, Janet Schroeder, and Carl Nordstrom.

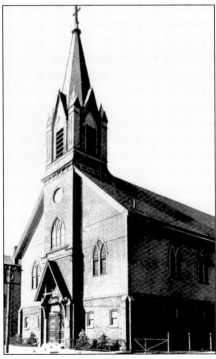

The Swedish Evangelical Lutheran Emanuel Church (Emanuel Lutheran) was organized in July 1896. Within two years, the vestry of the church was completed, while the finished edifice was not dedicated until November 19, 1899. The congregation worshiped in this church until the completion of the new building in 1961. The Quinsigamond Village Community Center is now housed in the structure. The church is shown here in a 1921 photograph.

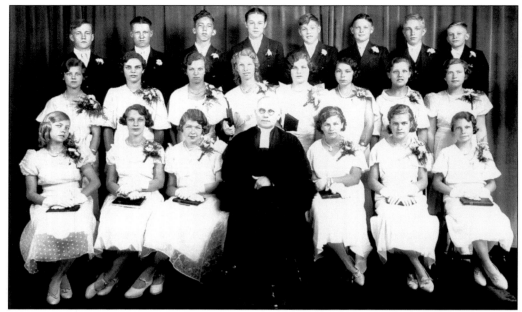

In this 1933 photograph, Pastor Albert J. Laurell poses with members of the Emanuel Lutheran Church confirmation class. Confirmed that June were Virginia Beklund, Gerda Mae L. Anderson, Anna M. Erickson, Signe D. H. Jacobson, Helen V. Wahlstrom, Inez Swenson, Stanley W. Schroeder, Edward W. Skoglund, Mary E. Walthen, Mildred E. Hammarstrom, Wilfred W. Falling, Ralph A. Thulin, Richard F. Gustafson, Eunice V. Becklund, Eleanor E. Laurell, Alice L. Tiderman, Ingrid S. Anderson, Betty Marie Hull, Robert L. Gustafson, Everett L. Frost, Jenney Ruohonen, and William O. Neimi. In 1923, Laurell was called from Valley Springs, South Dakota, to assume the pastorate at Emanuel and served the congregation for more than 20 years.

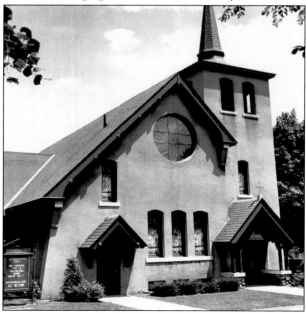

The cornerstone of the Evangelical Lutheran Zion Church was laid on August 6, 1916, and the vestry occupied in October. However, it would take another four years to complete the church itself. Seen here in 1963, the church was designed by Fuller & Delano in the popular Tudor-Gothic style.

Attending the 35th anniversary of the Zion Lutheran Church in October 1949 are, from left to right, Theodore E. Palmer and Martin L. Cornell (former pastors), Eric J. Gustavson (pastor at the time), and C. William Carlson (church founder and first pastor).

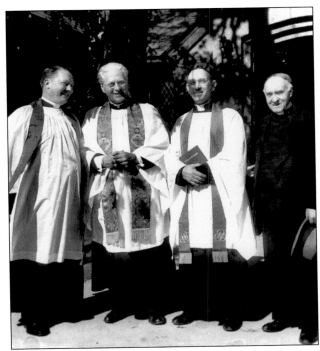

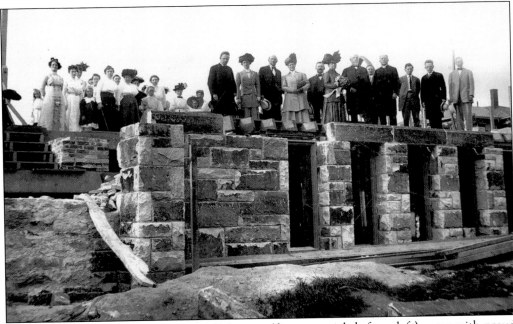

In this 1910 photograph, Pastor John Eckstrom (first row, eighth from left) poses with proud members of the Swedish Evangelical Lutheran Gethsemane congregation atop their new church building, then in the process of construction on Belmont Street. The granite blocks were salvaged from Worcester's old Union Station and purchased at a reduced price. In 1917, the congregation changed its name to First Lutheran and, in 1948, merged with two other congregations to form the Trinity Lutheran Church.

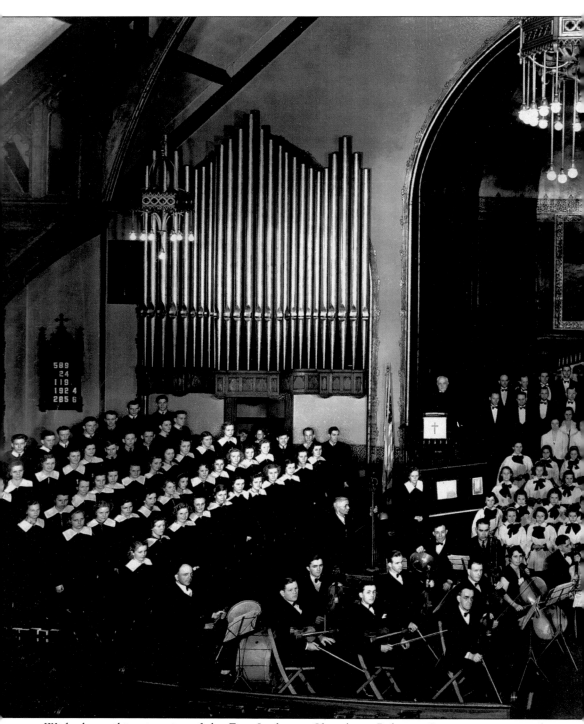

With the striking interior of the First Lutheran Church on Belmont Street as a setting, the congregation's musical groups gather for a photograph with Pastor John Eckstrom (at the pulpit) in 1938. The junior choir (left) and the senior choir (right) flank the Mendelssohn Singers

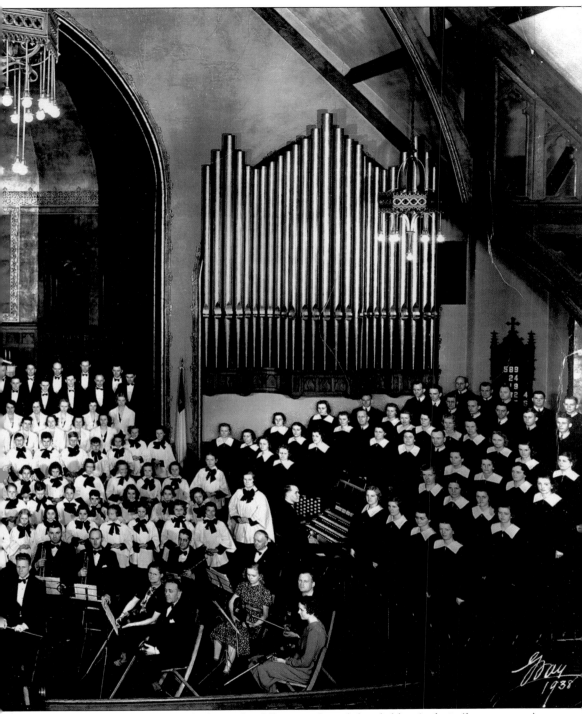

(upper center), the Jenny Lind Chorus (middle center), and the children's choir (lower center). The orchestra completes the portrait.

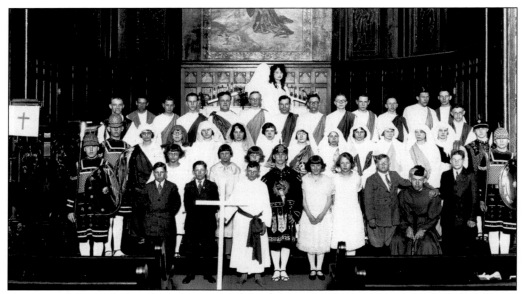

Young members of the First Lutheran Church presented a pageant entitled *A Pilgrim's Progress c*. 1920. Shown here, from left to right, are the following: (first row) Oscar Peterson, Clifford Lindberg, Eric Engstrom, four unidentified participants, Alden Pearson, Allan Gustafson, Theodore Peterson, and unidentified; (second row) ? Pearson, Evelyn Benson, Alice Johnson, and unidentified; (third row) Ella Nelson, unidentified, Dagmar Stromberg, unidentified, Edith Anderson, Astrid Carlson, Ebba Sund, Clara Anderson, Gunhild Turnquist, unidentified, Alma Kasparson, and unidentified; (fourth row) Walfred Larson, three unidentified participants, Fridolph Anderson, Theodore Englund, Gustaf Sandstrom, Irving Freudenthal, Arvid Anderson, two unidentified participants, Arthur Lindell, unidentified, and Thorsten Gustafson; (fifth row) unidentified.

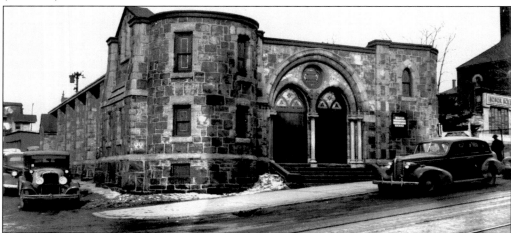

The Swedish-Finnish Lutheran congregation was organized in July 1900, and six years later, the lower vestry of the church (seen here *c*. 1940) was dedicated at the corner of Belmont and Carbon Streets. In 1928, the congregation changed its name to the Evangelical Lutheran Bethany Church and merged to form the Trinity Lutheran Church in 1948. The Swede-Finns, although smaller in number than both the Swedish and Finnish communities, organized several congregations. Unfortunately, the church was never completed according to the original plans.

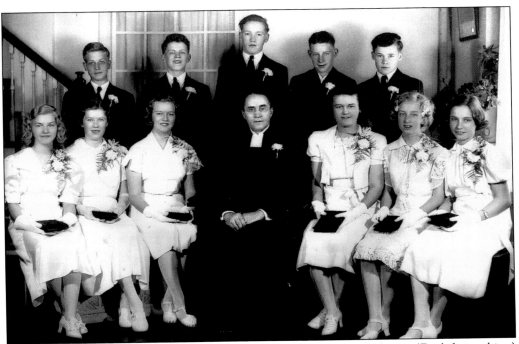

For several years, Bethany Lutheran (Swede-Finn) and Calvary Lutheran (English-speaking) celebrated joint confirmation ceremonies. In this photograph, the confirmation class of 1938 poses with Rev. Albin Lindegren at Calvary Lutheran on Salisbury Street. Confirmed from Bethany were Beatrice C. Holt and Pauline Johnson. Confirmed from Calvary were Raymond K. Bjorkman, Robert C. Carlson, Pauline A. Dahlquist, Robert A. Hagensen, Walter H. Hagensen, Phyllis Carolyn Harts, Arnold C. Knox, Louise E. Lindgren, and Gertrude M. Mills. In 1948, these two congregations joined with First Lutheran to form the Trinity Lutheran Church. Calvary was dismantled to make way for the new church.

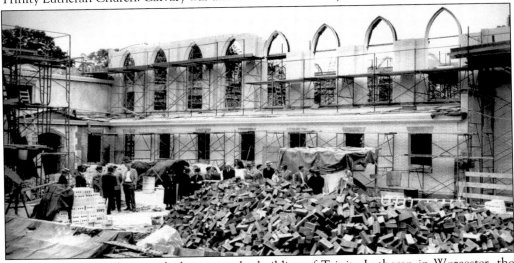

This and the next photograph document the building of Trinity Lutheran in Worcester, the most impressive of the region's Lutheran churches. In this scene, amidst a myriad of construction materials, interested congregants inspect the progress during a 1951 tour.

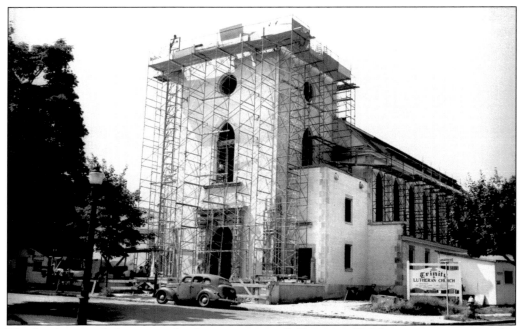

The familiar steeple began to take shape even as scaffolding engulfed the entire structure in this summer 1951 photograph of the Trinity Lutheran Church. The first services were held in the edifice that December, and the official consecration occurred on June 1, 1952.

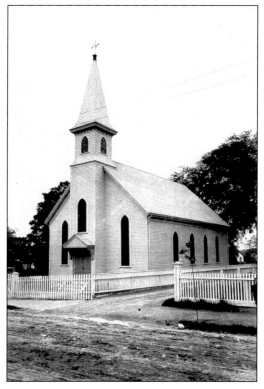

The Swedish community of Millville organized the Gustavus Adolphus Swedish Lutheran congregation in 1892 and a year later erected a small church. In 1921, the congregation partnered with the neighboring Swedish-Finnish congregation in Woonsocket, Rhode Island, and shared pastors. In 1961, the two parishes merged to form St. Mark Evangelical Lutheran Church in Woonsocket. Shown here in an early photograph is the original Millville edifice, later renamed the Zion Lutheran Church.

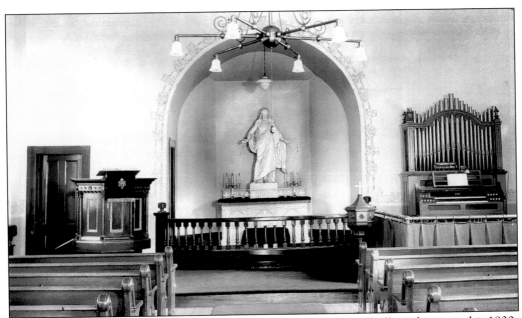

The interior of the Zion Lutheran Church on Central Street in Millville is shown in this 1930s photograph. The impressive statue of Christ now stands in the foyer of St. Mark Lutheran Church in Woonsocket, Rhode Island. The former Zion Lutheran edifice currently houses a Baptist congregation.

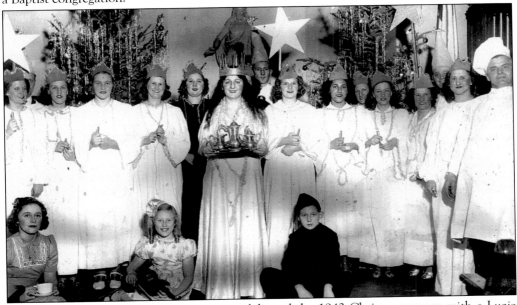

The Millville-Woonsocket congregations celebrated the 1942 Christmas season with a Lucia pageant at Zion Lutheran in Millville. Participants include, from left to right, unidentified, Doris Cook Greenglagh, Gladys Erickson Cadoret, Ruth Hauge Johnson, Harriet Gustafson Belseth, Mrs. Holmberg, Harold Belseth, Eleanor Hultquist Deon, unidentified, Alice Rose, Florence Wren Swahn, Judith Rose Carlson, Kenneth Eastman, Mildred Remblad Newlander, and unidentified. Three unidentified children sit in the foreground.

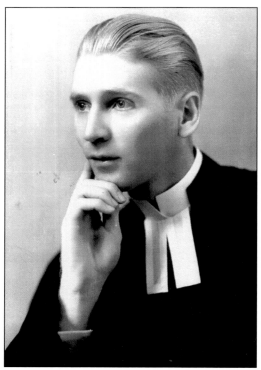

Striking an impressive pose in this *c.* 1938 portrait is the young Rev. Leonard W. Holmberg, pastor of the Millville-Woonsocket congregations. Holmberg arrived in 1937 and served as pastor until 1951.

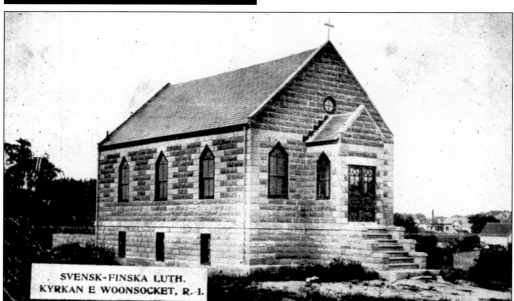

SVENSK-FINSKA LUTH.
KYRKAN E WOONSOCKET, R. I.

The Swede-Finn community in Woonsocket organized the Swedish-Finnish Evangelical Lutheran congregation (renamed Bethel Lutheran) in 1906 and erected a small church five years later. In 1921, the congregation partnered with Zion Lutheran in neighboring Millville and became a dual parish under the leadership of a single pastor. In May 1961, the two parishes merged and formed St. Mark Evangelical Lutheran Church in Woonsocket. Shown in this *c.* 1910 postcard is the Swedish-Finnish church amidst the open fields of Woonsocket.

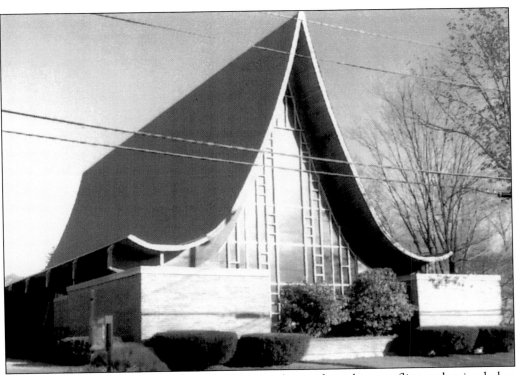

St. Mark Evangelical Lutheran Church of Woonsocket, with its sharp roofline and stained-glass front, was dedicated on June 21, 1964. Arland Dirlam, the architect of Emanuel Lutheran in Worcester, designed this exemplary edifice.

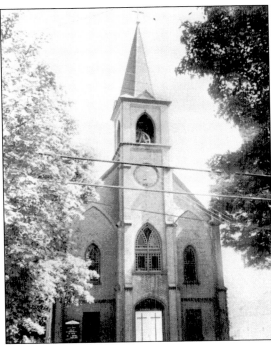

The Emanuel Swedish Evangelical Lutheran Church was established in August 1882 to serve the expanding Swedish American communities of Grosvenor Dale and North Grosvenor Dale, two villages located within the town of Thompson, Connecticut. Many arrived at the invitation of C. August Pearson, foreman of the Carding Department at the Grosvenor Dale Company. As the population increased, the original small wooden structure was replaced with a larger brick church, dedicated in 1897. The replacement church is pictured here c. 1962.

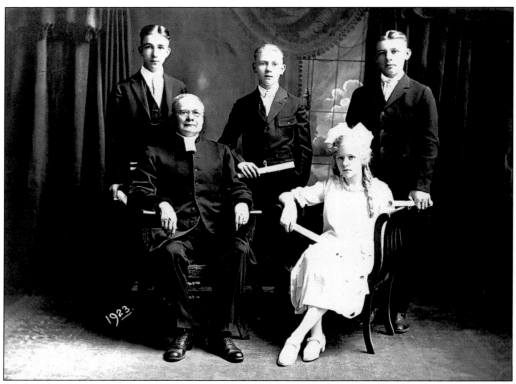

In this 1923 photograph, Rev. C. A. Lindevall poses with the small confirmation class of the Emanuel Lutheran Church in North Grosvenor Dale, Connecticut.

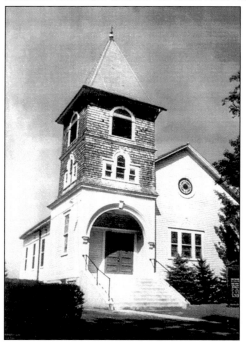

The first Swedish immigrants arrived in Woodstock, Connecticut, in 1871 as laborers for the prominent Dr. George Bowen. By the end of the decade, a sizeable Swedish American community had been established; most engaged in agriculture. In 1885, the Swedish Evangelical Congregational Church was organized. Six years later, the fledgling congregation purchased a blacksmith shop adjacent to the town common. The shop was rotated to face the common and renovated into a small church. A parsonage was constructed in 1893 and an educational wing in 1950. The Woodstock Church, as with most Swedish Congregational churches, joined the Mission Covenant Church. Shown in this 1940s photograph is the Evangelical Mission Covenant Church of Woodstock.

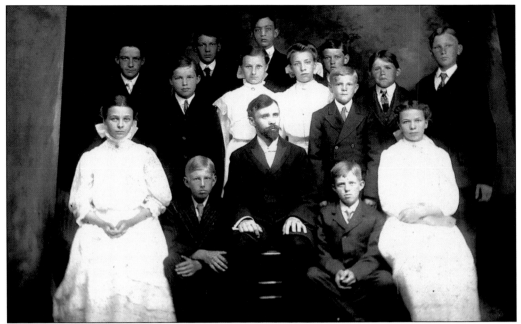

Members of the 1913 confirmation class of the Swedish Evangelical Congregational Church surround Rev. E. H. Elmquist in this studio photograph. Those confirmed that year in Woodstock, Connecticut, included Gustaf Petterson, Oscar Sanderson, Adolph Lawson, Albert Anderson, Frank Olson, Herbert Nelson, Edwin Olson, Martin Olson, Oscar Anderson, George Johnson, Hattie Johnson, Ellen Hagstrom, Esther Johnson, and Esther Nelson. Elmquist served the congregation for three years (1911–1914) before returning to Sweden.

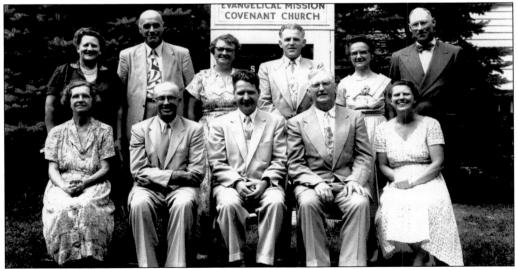

In 1955, the 40th anniversary of the 1915 confirmation class was held at the Evangelical Mission Covenant Church in Woodstock. Shown here with the pastor are, from left to right, the following members: (first row) Ellen Johnson Strand, Arvid Anderson, Rev. Walter Steen, Harry Strand, and Helen Bjornberg; (second row) unidentified, Emil Anderson, Julia Johnson, unidentified, Anna Johnson, and Paul Ringdahl.

This is to Certify that

Mr. Rudolph Bloom
20 Thenius' St.

is a member of

The Brotherhood Bible Class

of the

First Swedish Methodist Church

QUINSIGAMOND, WORCESTER, MASSACHUSETTS

1925

Herman Young, Pres.

Randolph Engstrom, Sec'y.

The motto of the Brotherhood Bible Class of the First Swedish Methodist Church in Quinsigamond Village was "Square to Everybody." In this sense, members discussed Bible teachings, current events, and fellowship toward all at their monthly meetings. Pictured is Rudolph Bloom's membership card for the year 1925.

BIBLISKA BERÄTTELSER

UR

NYA OCH GAMLA TESTAMENTET.

BARNENS FÖRSTA LÄROBOK

I

BIBLISKA HISTORIEN.

UTGIFVEN AF
GENERAL COUNCIL OF THE EVANGELICAL LUTHERAN CHURCH
I NORRA AMERIKA.

PÅ SVENSKA BEARBETAD AF

E. A. ZETTERSTRAND.

ROCK ISLAND, ILL.
AUGUSTANA BOOK CONCERN.

The Augustana Book Concern was organized in 1889 by the Augustana (Swedish) Lutheran Synod as a way of disseminating religious and other works in the Swedish and English language to Swedish Americans nationwide. The ABC was the largest Swedish American publishing company in the United States and continued operating until 1962. Shown here is a copy of *Bibliska Berättelser* (Bible Stories), promoted as "the Child's First Reader." This 1904 copy belonged to Elizabeth Pearson of Eastern Avenue in Worcester. She was likely able to maintain her knowledge of Swedish from books such as this.

THE
OF C(

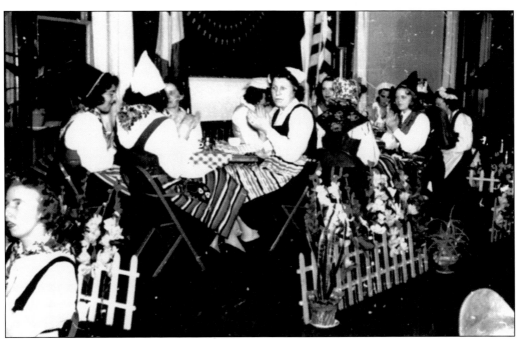

Swedish American congregations and organizations established a myriad of popular activities, and as a result, a plethora of established sports teams and musical groups proved popular with members. In addition, church picnics, special occasions, and public displays of ethnic pride united the community and promoted the social interaction of the Swedish American identity. In this 1938 photograph, guests in folk dress enjoy themselves at a Swedish American gathering at the Emanuel Lutheran Church in Quinsigamond Village, Worcester. The décor suggests an Easter festivity or a celebration of the Swedish American tercentenary, held throughout the country that June. Such celebrations strengthened the bonds of family and friends.

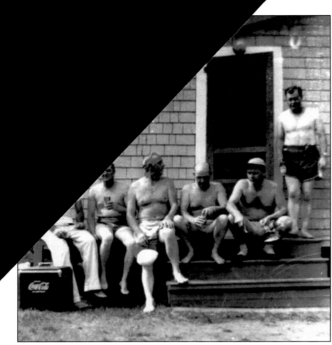

A group of Swedish Americans in the Greendale section of Worcester organized the Greendale Striper Club and established a clubhouse at Cape Cod's Monument Beach. In this 1950s photograph, avid fishermen gather for a weekend of summer fun. They are, from left to right, Henry Hendrickson, Ingve "Hilbert" Fern, Oke Nelson, Carl Lindberg, Ellis Gustafson, and Ray Carlson.

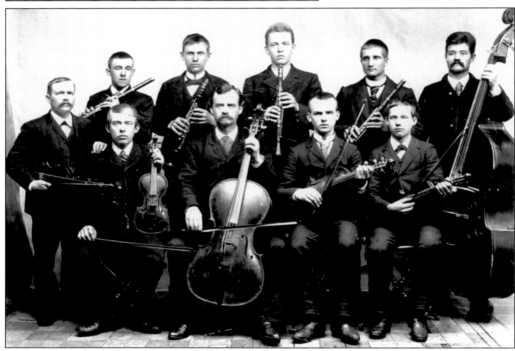

Music constituted an important part of the religious life of the Second Swedish Congregational Church (now Bethlehem Covenant) in Quinsigamond Village, Worcester. The congregation maintained a musical organization under the direction of J. Godberg even prior to the official organization of the church. In 1900, the string band pictured here was organized and for several years was directed by Peter Hoglund.

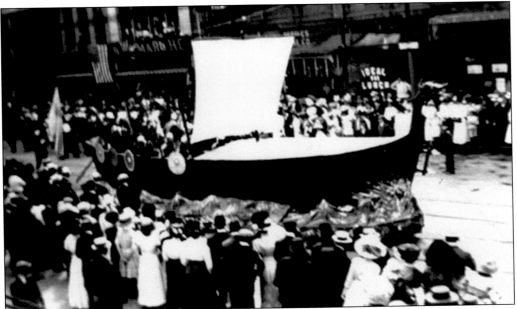

These remarkable photographs capture the Midsummer parade of 1912, the first large-scale public display of Swedish American pride to occur in Worcester County. Traversing the streets of Worcester is the Viking ship float sponsored by the Svea Gille Club. Horses were hidden inside the ship to give the appearance of floating. In addition, the ship "rocked" as if at sea. The 1912 Midsummer was the largest of its kind in the eastern United States.

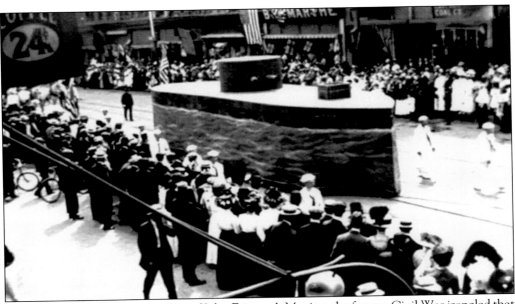

Another popular float was a replica of John Ericsson's *Monitor*, the famous Civil War ironclad that won a key battle for the Union. This float featured a rotating turret that spewed forth simulated smoke and fire. Parades like this were staples of the Midsummer celebration until the 1920s. Midsummer is still celebrated by Scandinavian American organizations throughout the region.

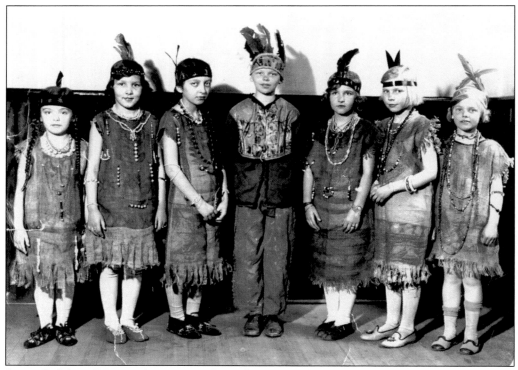

Some fledgling "Native Americans" from the Emanuel Lutheran Church in Quinsigamond Village pose prior to their 1930 pageant celebrating the Massachusetts tercentenary. Pictured here are, from left to right, Rigmor Erikson, Birgit Thulin, Birgitta Erikson, Karl Laurell, Ruth Sahlstrom, Phyllis Lundin, and Ruth Laurell. The neighborhood church was an important social and civic institution for many.

The latest Swedish movies were given special airings in Worcester County towns with large Swedish American populations. In this January 1937 advertisement from the Worcester paper *Svea*, the movie *Our Boy*, starring premier Swedish comedian Edvard Persson, was lauded as both "humorous and heartwarming." These releases kept Swedish Americans in tune with the popular culture of Sweden.

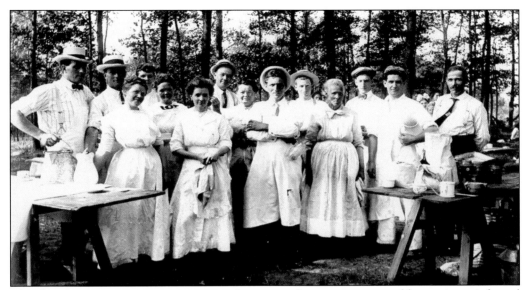

The church picnic was an important social occasion, for congregants could meet in an informal setting and enjoy the company of one another. Here, the kitchen crew of the Second Swedish Congregational Church (now Bethlehem Covenant) poses for the camera at Welch's Grove, along the shore of Ramshorn Pond in Sutton, *c.* 1905.

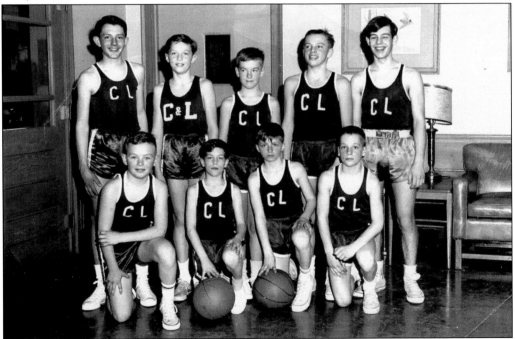

Recreational activities involved children of all ages and fostered a sense of sportsmanship. Seen here is the *c.* 1970 basketball team of Christ Lutheran Church in West Boylston. The players are, from left to right, as follows: (first row) Tommy Forsberg, Cory Pasquale, Ronald Rosenlund, and Ricky Benson; (second row) Jeff Paulin, Kurt Grundberg, Billy Forsberg, Robert Holm, and Joel Pasquale.

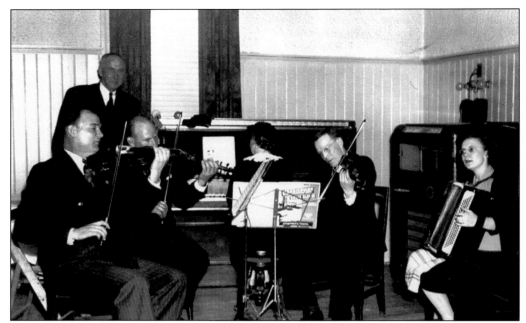

As director Yngve Greenlund (back left) looks on, musicians from the Swedish Folkdance Club entertain at the 89 Lincoln Street clubhouse during a performance c. 1948. From left to right are Yngve Nelson, Allen Jacobson, Marion Twigg, Paul Carlson, and Freda. Music was, and still is, an incredibly important force in community building.

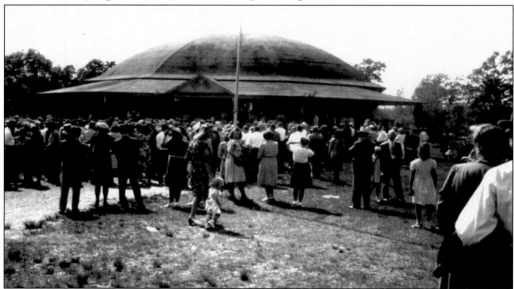

Crowds gather around the familiar domed clubhouse of the Scandinavian Athletic Club (SAC) during a Midsummer celebration in the 1940s. SAC Park was the area's premier gathering place for large-scale Swedish American events, particularly the annual Midsummer Festival sponsored by the Swedish National Federation. Swedish personalities, among them Ambassador Gunnar V. Jarring and the Öjebo Choir of Karlskoga, have participated throughout the years. SAC Park continues to host numerous area events and private parties.

Ethnic celebrations turned into family gatherings. In this 1946 photograph, Odin Blomquist (left) and his son Robert enjoy each other's company during a break in the Midsummer activities at SAC Park.

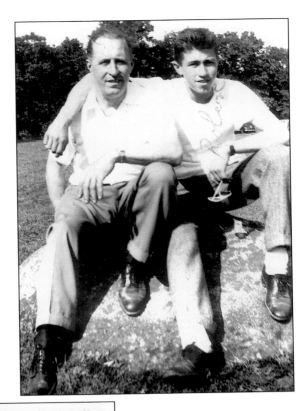

COME TO OUR OPENING DANCE

S. A. C. Park, Shrewsbury, Mass.

Saturday May 4, 1968

Dance to Nils Lundin's Orchestra

from 8 p. m. — to 1 a. m.

Admission $1.50.

DANS PÅ S. A. C. PARK

Hej grabbaroch jäntor,
nu blir det dans igen.
Kom till SAC Park med din vän.
Dans båd schottis och vals,
en liten svängdom skadar ej alls —
Lundin spelar på sitt klaver,
då behövs ej sägas något mer.
Inträdet är billigt — kom hit en och var
ta me' dej idn syster, bror och din far.
Men glöm inte morsan och kärestan din
kom till SAC blir du gla' i ditt sinn.
Den fjärde är datum och måna'n är maj
kom som du är med jäntan och hatten på svaj.

Spring marked the beginning of the dancing season at the numerous seasonal clubhouses located throughout Worcester County. In 1968, SAC Park heralded this rite of spring with a lyrical Swedish poem enticing would-be dancers to enjoy an evening out with family and friends.

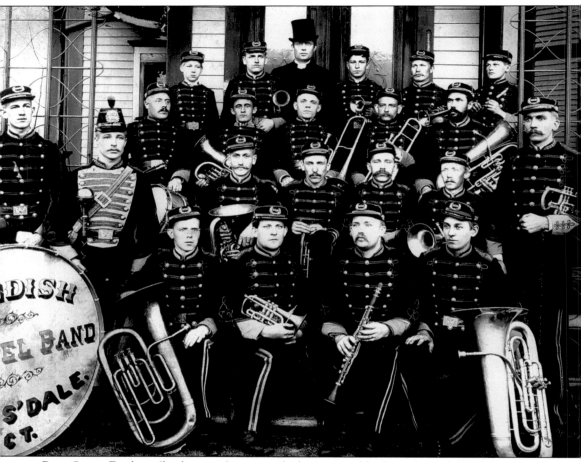

Rev. Göran Forsberg (back center) poses with the impeccably dressed members of the Swedish Emanuel Band on the steps of their original church in North Grosvenor Dale in 1895. Forsberg organized the band during his tenure from 1889 to 1905. Early reports indicate that this was the only church band among the eastern Augustana Lutheran congregations. The religious institutions sponsored a wide array of organizations, from social clubs to musical associations. As a result, many congregants became active participants in church life.

Massachusetts District No. 2 of the Vasa Order of America sponsored a series of popular "Vasa Flights" to Sweden during the 1960s and 1970s. These flights introduced many members of the Swedish American fraternal organization to the wonders of Sweden and brought members closer together through shared experiences. These trips were arranged by Rosenlund Travel Service of Worcester (misspelled on the banner), a business started in 1915 by Axel Rosenlund and still operated by family members. In this photograph, excited Vasa members and their families pose prior to takeoff at Boston's Logan Airport.

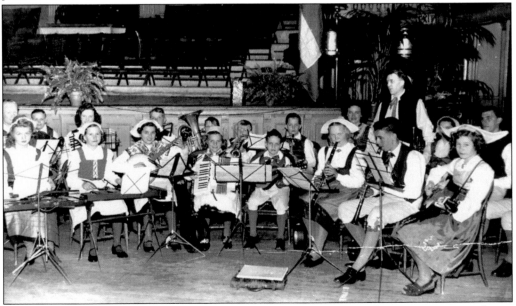

The Framåt (Forward) Club, the Vasa children's group established in Worcester, is shown here at Mechanics Hall in the 1940s. The Vasa Order promoted children's clubs as a way to perpetuate the Swedish culture. Children learned Swedish dances, songs, and as this picture illustrates, even music. At its height, the Vasa Order maintained more than 50 local lodges and several children's clubs statewide. Second from the left in the first row sits Norma Gustavson.

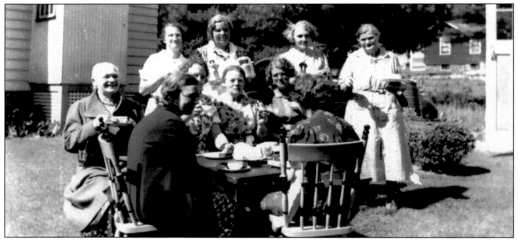

The Ladies' Aid Society of the Immanuel Lutheran Church enjoys a lighthearted moment during a 1936 outing at the home of Carl and Mabel Borgeson on Fairhill Road in Holden. From left to right are the following: (seated) two unidentified ladies, Anna Cook, Sophie Anderson, Ruth Tilman, and unidentified; (standing) Mrs. Henry Johnson, Mabel Borgeson, Elsie Johnson, and Amanda Borgeson. Oftentimes, ladies' organizations were instrumental in raising needed monies.

The church was the center of activity for many Swedish Americans. Extremely popular were the Sunday schools established by the various denominations. These schools introduced children to the world of the Bible and were originally used as tools for teaching the Swedish language as well. In this festive photograph, Sunday school students at the Salem Square Covenant Church entertain congregants at a 1952 Christmas program.

Initially, many Swedish Americans expressed great reluctance in supporting American entry into World War I. The Scandinavian American (and more notably German American) communities in America were subjected to disparaging attacks. Overt opposition quickly dissipated following the country's 1917 entry into the war, and expressions of loyal support became the rage. Here, the Spring 1918 Drill is presented by the ladies of the Thomas Street Methodist Church (Second Swedish Methodist congregation). Sweden is represented by Ruth Petterson Ericson (front, fourth from left). She is supported by five other nations portrayed by, from left to right, Florence Hedberg, Ellen Lofgren Soderberg, Edna Anderson Petterson, Esther Isberg, and Edith Nelson Lundmark. The doughboy, nurse, and sailor in the center are portrayed by Ruth Carlson Bergwall, Edith Grundstrom Elander, and Agnes Nordquist Otterson, respectively.

The 125th anniversary of Swedish immigration to Worcester was the impetus for Gå till Amerika (Go to America), an exhibit sponsored by the Worcester Historical Museum from October 1993 to March 1994. The exhibit brought together hundreds of artifacts loaned by the Swedish American community. In addition, the celebration featured special events, including a visit by the Swedish archbishop and a symposium of Swedish and American scholars. This exhibit gave rise to the publication of a book with the same name by Assumption College professors Charles Estus Sr. and John McClymer.

"gå till Amerika"

The Swedes in Worcester
1868-1993

through 31 March 1994
Booth Gallery
Worcester Historical Museum
Museum hours Tuesday–Saturday 10 a.m.–4 p.m.
Sunday 1–4 p.m.

"gå till Amerika" is a project of the Worcester Historical Museum, the Community Studies Program of Assumption College, and the Swedish-American community. The exhibition and related activities have been made possible by a grant from the National Endowment for the Humanities and contributions from businesses and individuals.

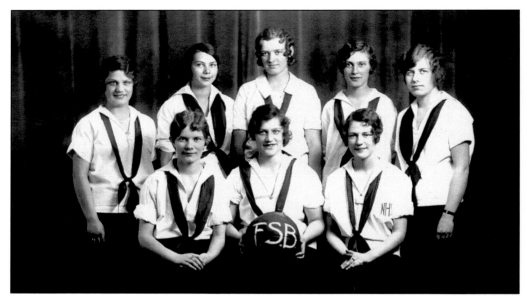

Many churches and organizations sponsored sports teams for women as well as men. Dressed in uniform, the women's basketball team of the First Swedish Baptist Church on Belmont Street poses *c.* 1925.

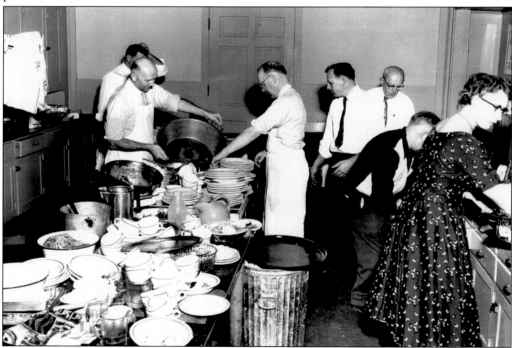

Every successful event depended on the behind-the-scenes efforts of many dedicated workers. In this June 1955 photograph, a busy kitchen crew cleans up after serving a meal at the annual meeting of the Evangelical Covenant Church, held at the Salem Square Covenant Church. Helpers include, from left to right, unidentified, Hjalmar Larson, Harold Berg, Dwight Goodale, Andrew Plantinga, unidentified, and Rachel Nordgren.

Six

THE PEOPLE
CALLED SWEDES

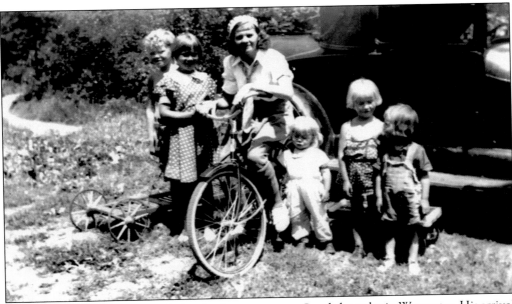

Carl Hanson is generally regarded as the first permanent Swedish settler in Worcester. His arrival in 1868 preceded large-scale Swedish immigration to Worcester County, although an earlier Swedish presence in the region has been documented. By World War II, Swedish Americans were, for the most part, the dominant ethnic group in Worcester, Auburn, and Holden, respectively. Thousands more were found in Worcester County and adjacent northern Windham County, Connecticut. Their presence is felt today in areas such as the New Sweden district in Woodstock, Connecticut, and in the Swede Hollow section of Charlton, Massachusetts. In this July 1937 photograph, taken on Wildwood Avenue in Worcester, a lighthearted Christine (Franson) Solomon plays the child. With Christine are, from left to right, cousins Thurston Solomon, Ellen Carlson, Marjorie Solomon, Virginia Carlson, and Carolyn Carlson.

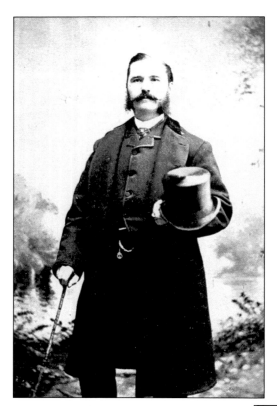

Dressed to impress, Carl "Charles" Fredrik Hanson is a dashing figure in this 1880s photograph. Hanson was born in Uddevalla, Sweden, and arrived in Boston in 1865. Having married, he arrived in Worcester with his family in 1868, thus becoming the first recorded permanent Swedish-born resident in the city. Hanson operated a successful music store and composed numerous works, among them the opera *Frithiof och Ingeborg*, which was performed in Worcester and Chicago.

Mildred Christina Bodvar wears her Salvation Army uniform in this 1935 portrait. Bodvar, a captain, was stationed at the corps in Gardner at the time. She was later stationed in Worcester and at the Scandinavian Salvation Army Headquarters in Boston.

West Sterling's one-room schoolhouse was the gathering place for this family picnic in the summer of 1942. This photograph captures the family matriarchs in a joyful mood. From left to right are Elin Sorblom, Birgitta Nordquist, Olga Ellner, Selma Anderson, and Sofia Hultgren. Family gatherings strengthened the bonds of kinship and provided many with fond memories.

Three-year-old Neil Janson, the son of Lillyan and Toga Janson, seems pleased behind the wheel of his tractor in this 1953 photograph taken in Northborough.

No Swedish American entertainer in Massachusetts has surpassed accordionist Nils Lundin in terms of popularity. Since the 1930s, composer-musician Lundin has performed throughout the United States and Sweden. In 1980, Sweden's King Carl XVI Gustaf honored him for his efforts in preserving Swedish culture in America. In that same year, the Massachusetts House of Representatives named him Man of the Year. Lundin is pictured here in a 1948 portrait.

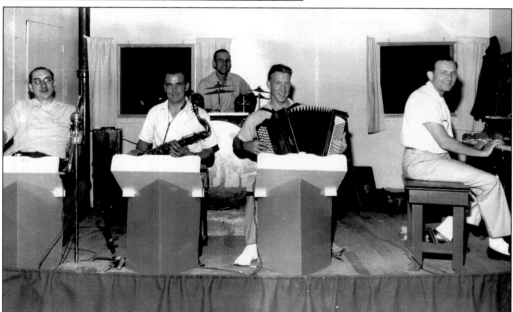

Pictured at SAC Park c. 1950 are, from left to right, trumpeter Arthur Whitten, an unidentified saxophone player, drummer Larry Sharp, accordionist Nils Lundin, and pianist Harry Locke. Beginning in 1955, the Nils Lundin Orchestra was featured on Paul Larson's radio program *SAC Party*, on station WNEB. For more than 20 years, the popular Saturday night dance program was broadcast from the dome room at SAC Park in Shrewsbury.

Beside a *smörgåsbord* bedecked with flowers and treats, Maria Carlson celebrates her 70th birthday with family and friends in 1954. Pictured with her is radio personality Paul Larson, a favorite among Worcester-area listeners, particularly Swedish Americans. Larson's radio programs *SAC Party* and *Scandinavian Hour* entertained generations until his untimely death in 1992 at age 68.

Patriotic symbols were proudly displayed during World War II. Enjoying a 1944 winter's visit to Purgatory Chasm in Sutton are, from left to right, Eleanor Laurell, Rigmor Erikson, sailor Karl Laurell, and Donald Kent. The star-studded park sign is clearly visible.

Swedish Americans willingly answered their country's call to arms in World War II. Impeccably dressed in his uniform, serviceman Hilding Nordstrom of Worcester poses upon his release from the army in January 1946. Nordstrom served in the European theater. Following the war, he worked for several years at the Anderson Corporation in Auburn.

Ellen Magnuson joined the Military Welfare Service of the American Red Cross during World War II and, by 1945, was serving in Great Britain. Upon returning, she joined the family firm, Worcester Tool and Stamping, with brothers Francis and Paul.

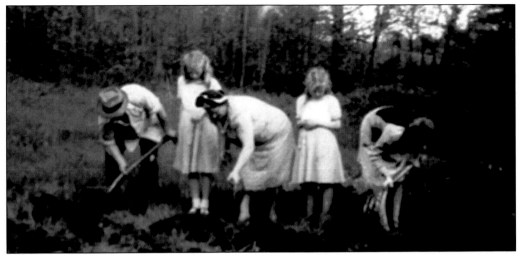

Victory gardens again became popular following the country's entry into World War II. Across the nation, families established their own subsistence gardens to alleviate food shortages. In this 1942 photograph, Nordstrom family members, from left to right, Carl, Esther, Edith, and Hulda lay out a garden with Esther Westlund at the Westlund home on Westlund Avenue in Auburn.

Several Worcester County Swedes were members of the Aquilo Club, the youth group of the Swedish Charitable Society of Greater Boston. The annual Aquilo Club Jul Bal-Luciafest attracted hundreds of attendees. Young women of Swedish descent between the ages of 17 and 21 were encouraged to register for the Lucia Bride contest. Here, members of the planning committee pose for a 1961 photograph. From left to right are the following: (first row) S. Gunnar Myrbeck, Karin Blom, and Col. Carl Larson of the Massachusetts State Police; (second row) Ernest Johnson, Gunvor (Nilsson) Gilbert, the Swedish consul, Siw Nilsson-Cedarblad, and Leif Kristiansson.

With the help of the family steamer trunk, aspiring young barber Karl Malmstrom assists his uncle Gustaf Peterson with his morning shave in this novel 1920 photograph taken at the Peterson home in Worcester.

A young Raymond Johnson smiles proudly for the camera c. 1928. In the background, the schoolhouse on Upsala Street is being enlarged. Opened in 1896, the elementary school served the upper Vernon Hill district, at that time a Swedish American enclave. Today, street names such as Upsala, Svea, and Lund recall the neighborhood's Swedish legacy.

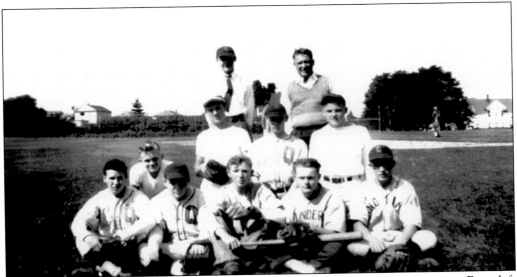

Fellow teammates pause before a 1942 baseball game in Greenwood Park, Worcester. From left to right are the following: (first row) Hilding Nordstrom, Jim Steinhilber, Norman Grundstrom, Bob Stevenson, and Bob White; (second row) Les Bjorklund, Al Tanona, Helge Nordstrom, and Wallace Johnson; (third row) Jack White and John White.

Wayne Lund (left) and his father, Warren, of Charlton enjoy a summer's outing amidst the flowers at the Gustafson farm, in the Swede Hollow section of town, c. 1945.

Kris Grundberg, a member of the Immanuel Lutheran Church basketball team, poses with his trophy at a 1968 awards banquet in Holden. An accomplished athlete, Grundberg moved to Sweden in 1977, where he enjoyed an impressive basketball career. He played for several teams, including Alvik, Hageby, and Linköping. At the 1980 Olympics, he played center for the Swedish national team. Grundberg now resides in Söderköping, where for many years he has coached the local basketball team.

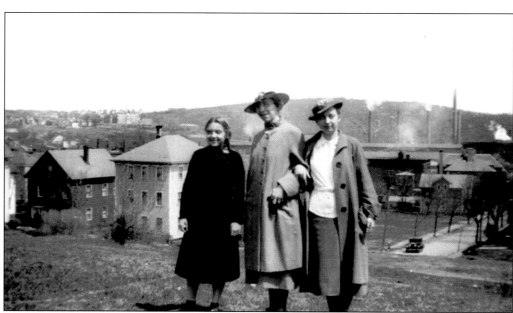

With a wonderful view of Quinsigamond Village and Vernon Hill, Rigmor, Elsa, and Birgitta Erikson pose for the camera c. 1933. In the background can be seen the Quinsigamond schoolhouses, the smokestacks of the American Steel and Wire complex, and Falmouth Street.

The "pony man" was a familiar neighborhood visitor during the 1930s and 1940s. For $1, children could have their photograph taken and fulfill the dream of playing cowboy or cowgirl for a few minutes. Here, Dorothy Trulson looks rather uncertain atop the visiting mare.

For most children, Christmas would not be the same without a visit to Santa Claus. In this 1963 photograph, the Stake brothers, Robert (left) and Ronald, share their Christmas wishes with Jolly Old St. Nick at the Frohsinn Club in Shrewsbury. The Stake brothers lived in the Edgemere section of town, a neighborhood with a high concentration of Swedish Americans.

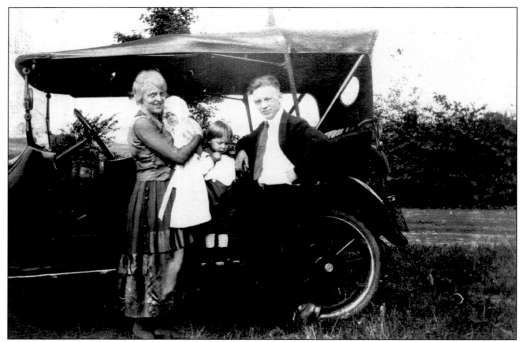

The Nordwells of Shrewsbury pose with their touring car c. 1920. From left to right are Agnes, Evelyn, Richard, and Carl Nordwell. Swedish Americans quickly became ardent participants in America's love affair with the automobile, as the nation took to the road in record numbers.

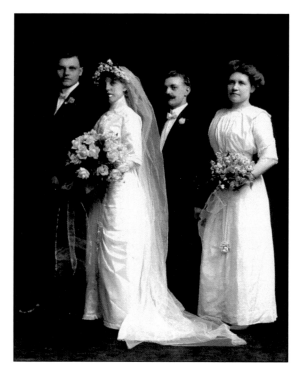

This wedding was certainly a family affair. Newlyweds Edward J. Fredrikson (left) and Ingrid C. Nilsson (second from left) pose with best man Nils Nilsson and maid of honor Levina Fredrikson in their 1913 wedding portrait. Both Edward and Ingrid were active in the affairs of the Scandinavian Salvation Army.

William O. Hultgren (center) stands with his parents, Otto W. and Pauline E., outside their 200-year-old Northside Road farm in Charlton in 1966. Following his graduation from the Stockbridge School of Agriculture at the University of Massachusetts, Amherst, William apprenticed at Göteborgs Trädgårdsförening. In Sweden, he acquired the folk costume of Bollebygd parish, Västergötland, his family's ancestral home. For several years, William wore the costume as a member of the Swedish Folkdance Club of Worcester.

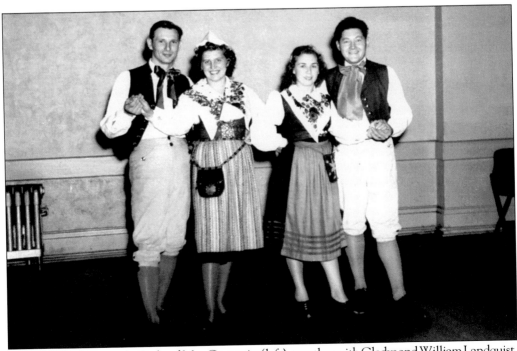

In this 1940s photograph, Carl and May Granquist (left), together with Gladys and William Landquist, pose in full dress, apparently ready for some festivity. Both couples were longtime members of the Swedish Folkdance Club, the Vasa Order, and the Swedish National Federation.

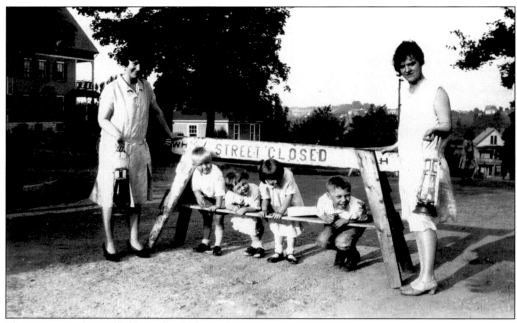

Florence Winberg (left) and Gladys Olson, signal lanterns in hand, oversee the Hastings Avenue paving project in Worcester during the summer of 1929. Their entourage of young assistants includes, from left to right, an unidentified child, Alice Brown, Edna Peterson, and Robert Brown.

Little Carl Oscar Nordstrom was in a rather petulant mood when this February 1944 photograph was taken on Whipple Street in Quinsigamond Village. The back reads, "He was mad and threw the hat off his head and walked away."

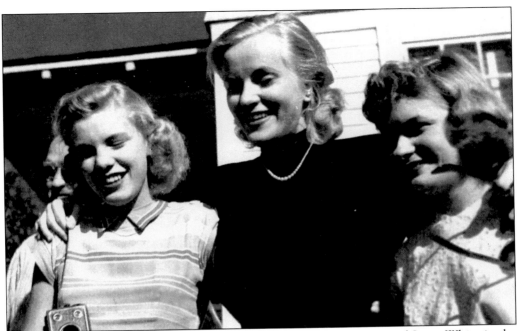

Swedish-born Tatiana Angelini was a radio star who became the voice of Snow White in the Swedish release of the popular Disney film. Her 1946 American debut included a performance at the Swedish National Federation Midsummer at SAC Park in Shrewsbury. In this 1948 photograph, Angelini (center) enjoys a lighthearted moment with friend Gunvor "Gunnie" Nilsson (left) and cousin Carolyn Gullberg of Millbury.

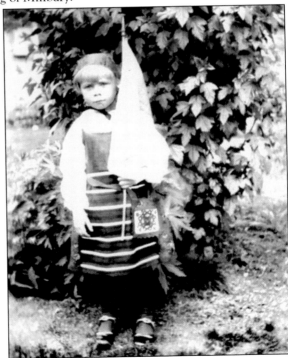

With Swedish flag in hand, Elaine Johnson is gaily adorned in a Rättvik folk costume at her Burncoat Street home in Worcester in 1931.

Dressed in his trademark disheveled garb, comedian and entertainer Nils F. Hagberg performs his routine in front of Worcester City Hall in 1961. One of Hagberg's oft-told stories dealt with an old Swedish uncle, a former sea captain buried at sea. "There was one sad part," he always lamented. "Two of his grandchildren drowned while digging the grave."

The musical talents of the Hagberg family are clearly evident in this 1965 photograph. Standing, from left to right, are Christine, Nils W., Susan, and Nils F. Seated at the piano are Audrey Hagberg and her daughter Robin. With musical roots extending back to Sweden, the Hagberg family name is well known throughout regional musical circles.

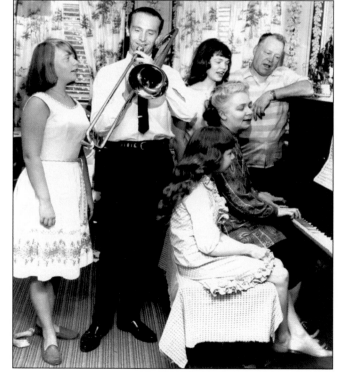

Howard Skoglund and Carolyn Gullberg, faces aglow, enjoy New Years Eve 1952 at the Svea Gille clubhouse at Lake Quinsigamond in Shrewsbury. Amidst the revelry of the evening, the two became engaged. Howard was a member of the Shrewsbury Police Department, while Carolyn was an accomplished area singer and organist. The Svea Gille clubhouse, dedicated in 1894, was a popular Swedish American landmark.

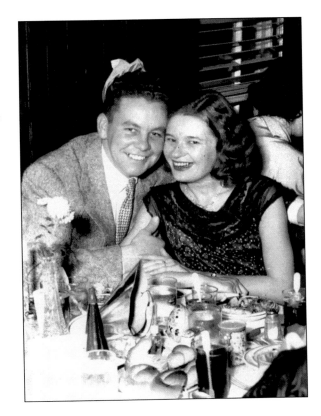

For many families, the weekends were full of home projects. In this c. 1946 photograph, the father-son team of Hilmer (left) and Thurston Solomon enjoy a moment's respite propped against the family's 1934 Dodge following a day of chores at their Swan Avenue home in Worcester.

Helen Nordstrom pours a cold drink for her eager daughter Karen at the Nordstrom family home in Worcester *c.* 1950. In the family's new electric refrigerator, a postwar sign of affluence, is fresh bottled milk from the Anderson Brothers Dairy of Quinsigamond Village.

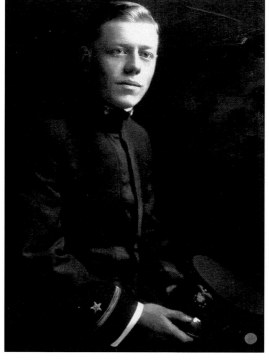

Andrew Holmstrom, seen here in a World War I–era portrait, attended Harvard Cadet School between 1917 and 1918 and served aboard the USS *Kilty* as an engineering officer. Following World War I, he was appointed a port officer in Venice, Italy. He was discharged in 1939 after 22 years in the U.S. Naval Reserve. Holmstrom enjoyed a successful career as a Worcester politician and top executive at the Norton Company.

Seven

ORGANIZATIONS FOR ALL NEEDS

A potpourri of social clubs, fraternal lodges, and benevolent organizations linked the Swedish population together. Clubhouses were constructed in cities and towns throughout the area, including the Kämpen Lodge camp in Worcester (1929); Svea Gille (1894) and the Scandinavian Athletic Club (1929) in Shrewsbury; Skogsblomman (c. 1922) in Auburn; and the Swedish Social Club (1905) in Westminster. National organizations such as the Vasa Order of America and the International Order of Good Templars established local lodges. By 1930, Swedish American organizations were an indelible part of the region's social sphere. Among the popular events sponsored by the Scandinavian Women's Gymnastic Club (organized in 1920) was an annual fall revue. These gaily dressed members formed the Pierriette and Pierot group that entertained audiences at Tuckerman Hall in November 1925. They are, from left to right, Anna Kjallstrand, Gunhild Blom, Evelyn Oberg, and Ina Oberg.

The Scandinavian Women's Gymnastic Club was eventually incorporated as the Scandinavian Women's Club. This social group was one of many that contributed to Fairlawn Hospital. In this 1955 photograph, a new orthopedic table is presented as a gift from the club. Posing with the new table at the hospital are, from left to right, the following: (first row) Astrid Gustafson, Dale Newman, Ingrid Cannon, Vivian Hedquist, Gladys Perrin, and Marie Johnson; (second row) Lillian Engstrand, Hjordis Rosenlund, Alberta Carlson, Edith Turnquist, Evelyn Sandstrom, Irma Stone, Pearl Nyman, and Virginia Carlson.

SWEDISH LUTHERAN OLD PEOPLE'S HOME

The Swedish Lutheran Old People's Home in Worcester celebrated the Christmas season by issuing this 1920s holiday postcard. As the first generation of Swedish Americans approached old age, the need for geriatric care became apparent. The New England Conference of the Augustana Lutheran Church thus established the home in 1920. It was enlarged in 1925 and 1979. Today, the Lutheran Home stands testament to the compassion of the Swedish American community.

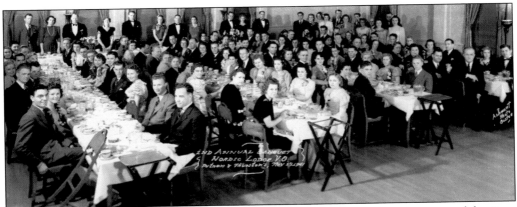

Members of Nordic Lodge No. 611, VOA, are shown at their second anniversary celebration, held on November 29, 1941. This lodge was the first English-speaking Vasa lodge organized in Worcester. Currently, Nordic is the largest Vasa lodge in Massachusetts, with more than 180 members.

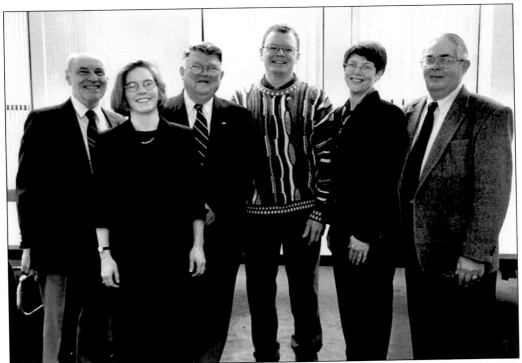

In December 2001, the Swedish National Federation (SNF) and the Worcester Swedish Charitable Association (WSCA) established a $75,000 scholarship fund for Worcester County high school students of Scandinavian descent through the Greater Worcester Community Foundation (GWCF). Seen here at the ceremony establishing the endowment are, from left to right, Robert Belden (SNF), Audrey Klein-Leach (GWCF), Jack Sundquist (WSCA), Eric J. Salomonsson (SNF), Ann T. Lisi (GWCF), and Howard Safstrom (WSCA). This fund guarantees the continuance of the scholarship tradition established in 1919 by the Swedish National Federation and made secure by the efforts of Arnold and Sylvia Nylund.

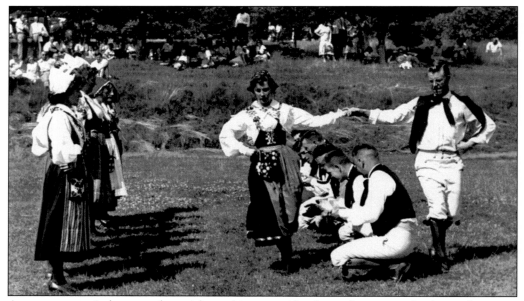

A warm summer's day, complete with sunshine, provides the perfect setting for this performance of the Swedish Folkdance Club (organized in 1941). For generations, Swedish Americans across the region gathered at SAC Park to enjoy the annual Midsummer Festival, sponsored by the Swedish National Federation. This important ethnic celebration was highlighted by sports events, children's performances, music, and of course dancing. In this *c.* 1945 photograph, Emma Lundquist (left) watches dancers as they waltz over fellow members to the delight of the crowd.

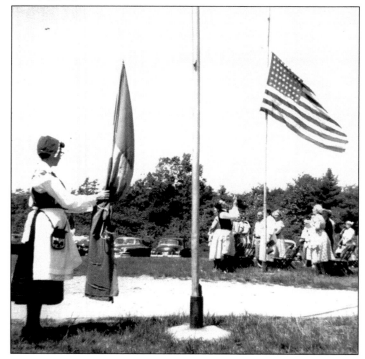

At a 1950s Midsummer Festival at SAC Park in Shrewsbury, Norma Ahlberg (left) and her husband, Kenneth, raise the Swedish and American flags and thus announce the beginning of a weekend of festivities.

On June 17, 1926, Crown Prince Gustaf Adolf of Sweden and his wife, Crown Princess Louise, toured Worcester. Among the sites visited were the Swedish Lutheran Old People's Home and Fairlawn Hospital. That afternoon, the royal couple attended the Swedish National Federation Midsummer Festival at the Agricultural Grounds in Greendale, where they were greeted by thousands of well-wishers. The Midsummer Festival program shown here features portraits of the prince and princess.

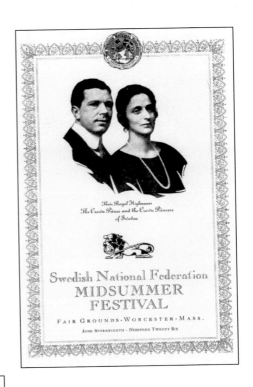

Their Royal Highnesses
The Crown Prince and the Crown Princess
of Sweden

Swedish National Federation
MIDSUMMER
FESTIVAL
FAIR GROUNDS · WORCESTER · MASS.
June Seventeenth · Nineteen Twenty Six

I. O. G. T. DOUBLE QUARTETTE

First row: E. H. Nordstrom, Gunnar Larson, Victor Rosenlund, Ragnar Flodstrom.
Second row: Ernst Froberg, Eugene Hansen, Adolf Anderson, Conrad Olson.

Tour in Sweden:

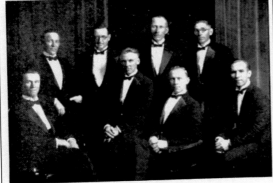

June	18	Alingsås	
	19	Borås	
	20	Jönköping	
	21–22	Tranås	
	23–24	Örebro	
	25	Lindesberg	
	26	Lesjöfors	
	27	Karlskoga	
	28–29	Arvika	
	30	Munkfors	
July	1	Karlstad	
	2	Skogshall	
	3	Nykroppa	
	4	Motala	
	5	Norrköping	
	6	Linköping	

7	Oxelösund
8–9	Södertelje
10	Eskilstuna
11	Kungsör
16	Stockholm
	Köping
	Hallstahammar
	Sala
	Västerås
	Upsala
	Gävle
	Visby
	Halmstad
	Falkenberg
	Varberg
	Göteborg

Mr. Victor Lindmark
Lindesberg
Impressario in Sweden

Members of the Scandinavian Good Templar lodges in Worcester organized the Double Quartet in January 1924. During the summer of 1930, the group made a highly publicized tour of Sweden in conjunction with the convention of the International Order of Good Templars in Stockholm that year. Quartet members and their itinerary are shown here. In 1937, the name of the group changed to the Swedish Singers. The advent of World War II affected membership, and the Singers eventually disbanded.

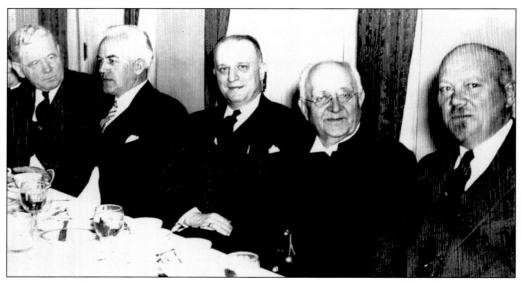

The Odin Club (organized in 1920) was a Worcester-area group of Swedish American businessmen and civic leaders. In April 1939, Pastor John A. Eckstrom of the First Lutheran Church was honored at a testimonial dinner sponsored by the club. The prominent men shown here are, from left to right, Dr. F. Julius Quist, Pastor Anders Lund of the Bethlehem Evangelical Church, Harry Fager (club vice president), John Eckstrom, and Dr. W. Elmer Ekblaw (noted Clark University geographer and club president).

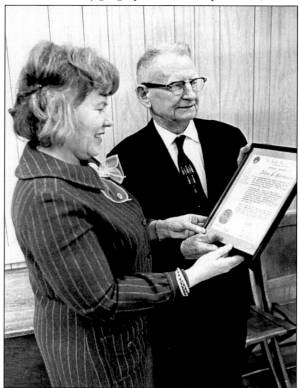

In this 1973 photograph, Frances Gadde (president of the Swedish National Federation) presents lawyer John E. Bjorkman with an honorary membership in the organization. Over the years, recipients have included Prof. Robert N. Beck of Clark University and Judge Carl E. Wahlstrom. With roots dating to 1903, the Swedish National Federation is the premier Swedish American organization responsible for the maintenance of the Swedish heritage in the Worcester area.

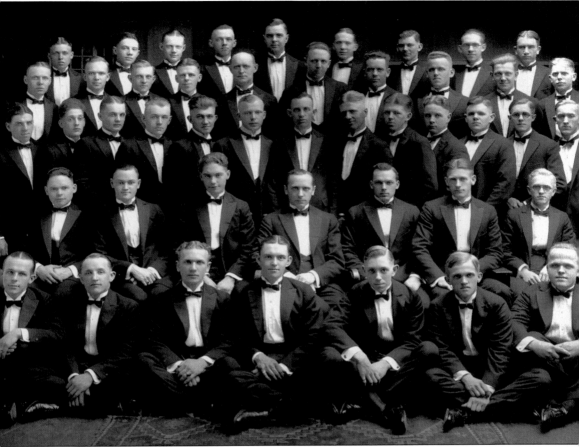

The musical group formed at First Lutheran Church in 1920 became known as the Mendelssohn Singers. This association was one of the more popular and longest-surviving musical organizations of Swedish Worcester. Pictured here in the 1920s are, from left to right, the following: (first row) Carl Larson, Henry Peterson, Eric Hillsen, Henry Ambruson, Oscar Gabrielson, Iver Gustavson, and Fridolf Anderson; (second row) Helge Siltberg, Arthur Paulson, Hilding Lund, J. Fritz Hartz, Victor Dahlquist, Harry Nylin, and Harold Bergquist; (third row) Art Olson, Rudolf Werme, Ted Johnson, Alan Gustafson, Herbert Nord, George Nelson, George Johnson, Carl Lind, Bert Schon, Phil Westerlind, Carl Forsberg, Irving Freudenthal, and Ed Rudman; (fourth row) Carl Carlberg, Al Larson, Walter Gustafson, unidentified, Thure Hanson, George Person, Dave Russel, Helge Pearson, Arthur Gustafson, and Lennart Kasperson; (fifth row) ? Carlson, unidentified, Duncan Gilles, Dick Englund, unidentified, ? Swenson, Albert Turnquist, Carl Anderson, and Fred Russel.

The Scandinavian Societies' Building Association was formed in 1921 with the goal of establishing a headquarters for the area's Scandinavian American groups. In 1926, the stately Governor Davis Mansion, at 89 Lincoln Street, was purchased, and dedication ceremonies were held that September. For decades, 89 Lincoln Street was the meeting place for dozens of organizations. In 1927, Prince Wilhelm of Sweden visited the home and signed the guest register. Unfortunately, the construction of Interstate 290 doomed the historic structure, which was demolished in 1961.

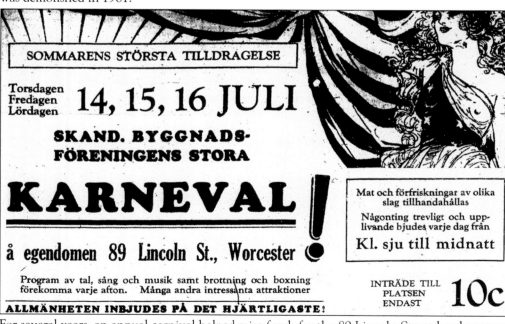

SOMMARENS STÖRSTA TILLDRAGELSE

Torsdagen
Fredagen
Lördagen
14, 15, 16 JULI

**SKAND. BYGGNADS-
FÖRENINGENS STORA**

KARNEVAL!

å egendomen 89 Lincoln St., Worcester

Program av tal, sång och musik samt brottning och boxning förekomma varje afton. Många andra intressanta attraktioner

ALLMÄNHETEN INBJUDES PÅ DET HJÄRTLIGASTE!

Mat och förfriskningar av olika slag tillhandahållas

Någonting trevligt och upplivande bjudes varje dag från

Kl. sju till midnatt

INTRÄDE TILL
PLATSEN
ENDAST
10c

For several years, an annual carnival helped raise funds for the 89 Lincoln Street headquarters. This advertisement from *Svea* promotes the 1927 festival as a "program of talks, song, and music together with wrestling and boxing occurring every afternoon." This fund-raiser was a much-anticipated event within the Scandinavian American community.

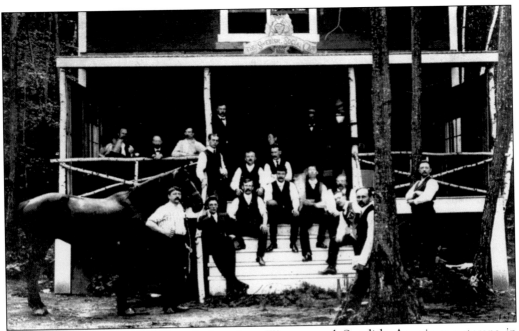

Following the end of the Spanish-American War, several Swedish American veterans in Gardner gathered to promote fellowship. On September 16, 1900, eighteen men organized the Swedish Social Club. Five years later, land was purchased and a camp constructed along the shores of a local pond. In this 1910 photograph, members proudly pose in front of their clubhouse amidst the woods of northern Worcester County.

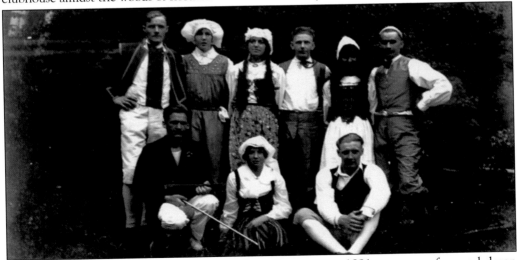

Quinsigamonds Väl Lodge No. 1, organized in Worcester in 1891, was one of several dozen Scandinavian lodges within Massachusetts belonging to the International Order of Good Templars (a temperance organization). In this 1925 photograph, the lodge's folk dance group poses for a snapshot at a Templar outing in Fitchburg. From left to right are the following: (first row) Ivar Erickson, Ethel Ohrn, and Sven Hallberg; (second row) John and Huldur Lawrence, Magnhild and Emanuel Erickson, and Märta and Axel Eriksson. Scandinavians in Fitchburg and Gardner organized temperance lodges of their own.

Members of *Nordavind* (North Wind), the youth group of the Quinsigamonds Väl Lodge, pose at their IOGT lodge home in Worcester *c.* 1930. From left to right are the following: (first row) Hjordis (Thyden) Rosenlund, Emmanuel Erickson, Sven Hallberg, Lydia Williamson, John Youngberg, and Marie Rosenlund; (second row) Josefina Carlson, Astrid Grusell, Märta Eriksson, Hildur Lawrence, Ethel Ohrn, Christina Tiderman, Magnhild (Hanson) Erickson, Axel Eriksson, and John Lawrence; (third row) Eric Grusell, Bror Josef Rosenlund, Gunnar Larson, Alva Erickson, Joseph Johnson, Olof Bokelund, Ernest Froberg, and Harry Person; (fourth row) Victor Rosenlund, Nils Anderson, Henning Nelson, Harry Hanson, Axel Tiderman, Harry Thyden, and Alfred Landgren.

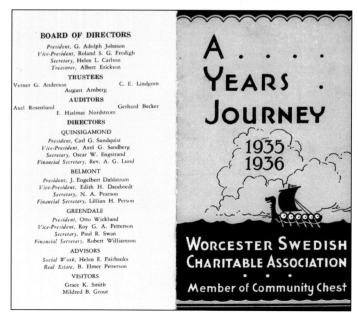

The Worcester Swedish Charitable Association (established in 1901) helped needy Swedish Americans with financial, social, and medical assistance for 103 years. The 1935–1936 annual report notes, "94 families required financial services, 74 families needed family services only. . . . Personality problems or mental distress is found in every fifth of our homes." The Swedes suffered from the same social ills that affected every community.

A myriad of local Swedish American organizations participated in the 250th anniversary parade celebrating Worcester's town incorporation. In this 1972 snapshot, various groups ready themselves behind a banner proclaiming, "The Swedish Organizations of Worcester." The flags of America and Sweden can clearly be seen, as is the flag of the Vasa Order of America.

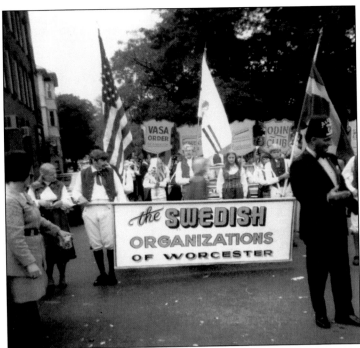

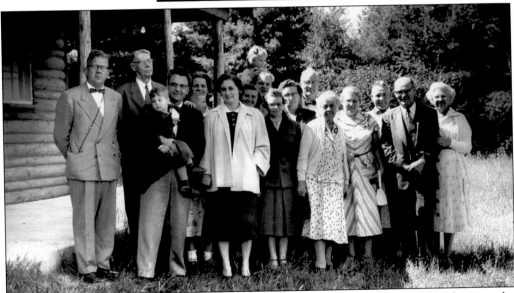

Representatives of the Scandinavian Ministerial Association pose at Camp Charlton on the shores of the South Charlton Reservoir in September 1955. Attendees include Rev. and Mrs. Milton Satterberg (Grace Baptist), Rev. O. G. and Mrs. Norseen (Salem Square Covenant), Rev. and Mrs. Ralph Manwiller (Quinsigamond Methodist), Rev. Wallace and Edith Cederleaf (Chaffins Congregational), Rev. Virgil and Lillian Wickman (Bethlehem Covenant), Rev. and Mrs. Andrew Holmgren (Bethel Baptist), and Rev. and Mrs. Oscar Anderson (Belmont Street Baptist). This campground was acquired by the Salem Square Congregational Church as a gift from the Berg family in 1947. Co-author Philip Becker designed the rustic lodge to the left.

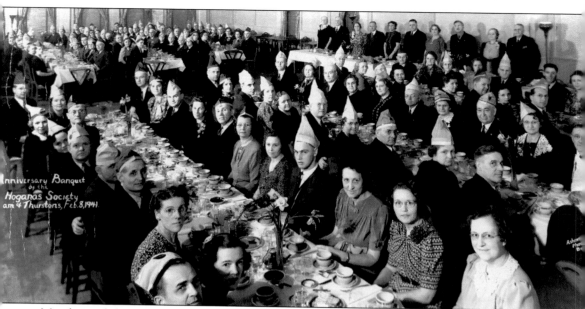

Members of the Höganäs Society celebrate the group's anniversary in February 1941 at the Putnam and Thurston Restaurant in Worcester. Organized in 1904, the society consisted of natives and their offspring from this southern Swedish coastal town. Hundreds of Höganäs residents became employed at the Norton Company in Greendale, encouraged to emigrate by company co-founder and factory superintendent John Jeppson, a fellow townsman.

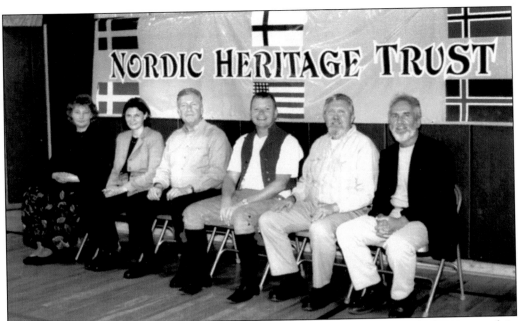

The Nordic Heritage Trust was organized in 1998 by a group of individuals interested in documenting and preserving the written record of the region's Scandinavian Americans. A small archive was established, and the group hosted the October 2003 visit of the Swedish American Historical Society to Worcester. In this 2000 photograph, charter members pose at an event in Holden. From left to right are Lee Ann Amend, an unidentified participant, George Hultgren, Eric Salomonsson, William Hultgren, and local Finnish American historian Barry Heiniluoma.

Another "second-generation" organization is the Swedish Ancestry Research Association (SARA), established in Worcester in 1994 as a genealogical research organization for Swedish Americans. Since its inception, the group has helped hundreds of individuals locate ancestors both in the United States and Sweden. SARA maintains a Web site and participates in state events, most notably the large Swedish Christmas fair sponsored by SWEA of Boston.

The Swedish American legacy is literally etched in stone throughout the region. The Jeppson family memorial stone at Old Swedish Cemetery in Worcester is one of the more elaborate markers. It is an imposing structure more than six feet high and inscribed with a fleet of Viking ships, Runic symbols, and Psalm 23. Its position at the entrance to the cemetery denotes the family's importance within both the Swedish American and Worcester communities.

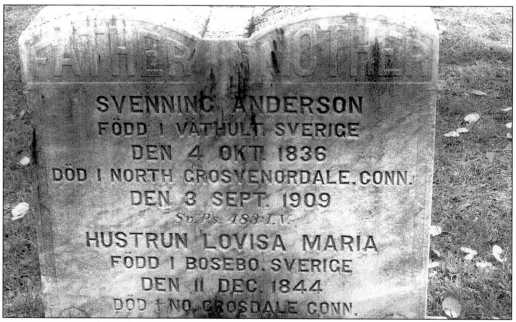

Many stones, such as the marker of Svenning and Louisa Anderson, appear in the Swedish language. This particular gravestone is found in the old Emanuel Swedish Evangelical Lutheran Church burial ground in North Grosvenor Dale, Connecticut.

BURIED IN OLD SWEDISH CEMETERY

SPANISH WAR VETERANS

Carl G. Bjornquist	Fabian Hakanson	John E. Kolburn	Abel Nilsson
Gustaf E. Broman	Harry O. Hedlund	Sten Eric Lindblad	Carl Oberg
Svan H. Carlberg	Adolf G. Johansen	Carl A. Lundberg	John Olsen
John E. Carlson	Theodore J. Johnson	J. V. Maller	Oskar T. Petterson
John G. Hagberg	John Peter Kamb	Ragnar Mellin	Erick U. Sundberg
Dr. J. Hagerty			

WORLD WAR I VETERANS

Carl Abrahamson	Elis Ek	Elmer Johnson	H. G. Nordquist
H. L. Aldrin	George E. Eklund	F. L. Johnson	Frederick Nystrom
Paul Allen	R. Englund	Ernest A. Johnson	Herbert E. Nystrom
Arvid R. Anderson	Hjalmar A. Erickson	Francis L. Johnson	Otto M. Olson
Carl G. Anderson	Harry G. Fager	G. Johnson	Carl V. Parath
Eric C. Anderson	Rudolf L. Fagerstrom	George A. Johnson	Henry Parath
Frans L. Anderson	Arthur E. Fagerquist	John V. Johnson	Ansel D. Parke
H. W. Anderson	L. Fagerquist	Paul Johnson	H. E. Peterson
R. Anderson	Carl V. Falling	Philip H. Johnson	Eskil V. Renblom
Ernest R. Benson	George R. Finne	Thure F. Johnson	Ernest J. Rousseau
Fritiof W. Berg	A. W. Flink	Carl A. Korp	John Bertil Sandquist
John Berg	H. Gardner	R. Lagerholm	O. Sjoblad
Carl Berglund	Carl W. Glassberg	A. A. Landin	David E. Sjogren
C. G. Bergman	Herbert T. Granat	E. Lind	Frederick R. Skoglund
G. Bergstrom	Ivar H. Granquist	Roger Lindgren	C. H. Smith
Charles A. Bjorkman	Ivar G. Grundstrom	G. V. Loff	Joseph Smith
E. G. Blomgren	Edwin E. Hagen	P. Loff	Rudolph Soderlund
Allan H. Bohlin	Nils I. Hallberg	David E. Lofstrom	D. W. Stohlberg
George Burlin	Olga C. Hallstrom	Edward O. Ludvigson	H. E. Stonequist
B. Carlson	Albin Hammarstrom	C. J. Lund	Carl J. Sund
E. B. Carlson	Victor Hjort	Victor E. Lundgren	C. R. Swenson
E. P. Carlson	George Holmes	C. A. Lygdman	H. W. Ulfves
Ernest L. Carlson	A. M. C. Johnson	Joseph I. Maller	Harry Ulman
George P. Carlstrom	Arvid V. Johnson	C. N. Marshall	Harry W. Uppstrom
Arthur E. Dahlquist	Carl J. Johnson	M. A. Nilson	Henry Werre
Gus. A. Einar	D. W. Johnson	A. W. Nilsson	

WORLD WAR II VETERANS

Peter Sture Carlson	Gustave E. Korp	Harold A. Madsen	Irving N. Syrene
Carl H. Colburn	William Korp	Elmer A. Mattson	
David S. Johnson	August D. Linneros	Mildred S. Peterson	
Helmer M. Kallstrom	Clifford E. Lundblad	Martin R. Sandberg	

KOREAN WAR VETERANS

Walter G. Armstrong

PEACE TIME VETERANS (ON ACTIVE DUTY AT TIME OF DEATH)

Norman E. Anderson

BURIED IN THE NEW SWEDISH CEMETERY

SPANISH WAR VETERANS

John F. Bergstrom	Charles G. Forsberg	Carl O. Hjelm	Carl F. Lundstrom
William J. Bjorkman	Sigurd Freudenthal**	Robert F. Lindstrom	Charles O. Swanson
Axel Erickson	Walter N. Gutkey	Charles L. Lundstrom	Martin Swanson

WORLD WAR I VETERANS

Carl L. Abramson	James F. Cox	John A. Johnson	John Palmer, Sr.
John E. Ahlstrom	Raymond J. Downey	John L. Johnson	Charles G. Peterson
Chester C. Agnew	Lars J. G. Dahl	P. Paul Johnson	Gideon R. Peterson
Adolph A. Anderson	E. Russell Enberg	Steen L. Johnson	Ralph C. Peterson
Axel S. Anderson	Axel R. Engstrom	Arvid W. Larson	Ruth E. Rolander
Edwin W. Anderson	Leon E. Erskine	Lorits L. Levin	Clarence D. Rose
Oscar A. Anderson	E. C. Fallstrom	George W. Lindberg	J. E. Alfred Rousseau
Wilfred A. Anderson	William J. Fallstrom	Albert S. Lindblom	Gustaf R. Rundstrom
Walter Anderson	Bernard O. Flodin	Arvid L. Lindquist	William F. Sandquist
Harry Arnberg	John Alvin Freeland	Anders M. Landgren	Carl J. Sandstrom
Frank L. Barnes	Axel L. Gullbrand	Roger C. Lindgren	David T. Sandstrom
Carl A. Becker	Paul A. Gustafson	Vernie C. Lindgren	Alfred W. Seidel
Elmer R. Beckman	Otto A. Haglund	Arthur G. Ljungberg	Charles A. Snickers
Albert Carl Berg	Arvid Hanson	Arvid R. Loff	Joseph Saponski
John Berg	Henry Hammar	A. G. Londgren	Harry E. Skantz
John Bergman	Arthur R. Hanson	John A. Lund	Arthur Smith
Gustaf A. Bergstrom	Herb. M. Harrington	J. C. Madsen	John E. Strandberg
Lawrence D. Borg	Hans Haugaard	Ernest A. Mangs	Gustaf E. Stockhaus
Sterner E. Borg	Mauritz Hedlund	John E. Mantilla	Andrew Sundin
Louis M. Bray	Oscar H. Hendrickson	Fred Mara	John W. Sundstrom
Signet Brickman	Eric W. Hjulstrom	Victor Marcinkus	Hilmer T. Sundstrom
S. A. Broberg	Sigfrid M. Holmes	John A. Mattson	Frank L. Swanson
Ragnar Broman	Omar A. Hoyt	Carl R. Mickelson	Ragnar O. Swenson
Steve A. Brote	Philip Hult	Arthur A. Moore	Oke A. Swahnberg
August E. Carlberg	Arvid E. Jacobson	E. L. Nelson	Carl G. Thyden
Albert E. Carlson	Albert E. Johnson	Edward M. Nelson	Sigfrid Trulson
Charles H. Carlson	Axel Johnson	G. W. Nelson	R. A. Twilcott
Gustaf W. Carlson	Carl F. Johnson	Henry J. Noponen	Frank G. Warner
J. A. Charboneau	Carl I. Johnson	A. C. Nordahl	Walter F. Wickstrom
Christian Christianson	David W. Johnson	*Winfield E. Ohlson	Philip J. Widegren
C. Albert Croone	Emil Johnson	Oscar C. Orstrom	Fred L. Wilkinson

WORLD WAR II VETERANS

Carl E. Anderson	Carl G. Dahlgren	Ingve A. Johnson	Walter F. Peterson
Carl G. Anderson	Carl D. Edgren	Paul W. Johnson	William A. Peterson
George Walter Anderson	George F. Ekstrom	John A. Josephson	Theodore G. Peterson
Martin E. Anderson	Harold L. Erikson	Waino W. Kallioniemi	Wesley C. Pierson
Roy A. Anderson	Hugo W. Finne	Albert B. Lindgren	Sulo H. Pietila
Norman B. Bergdahl	Albert J. George	John R. Lundberg	Harold N. Rodger, Jr.
Harry G. Berglund	Oscar A. Hagberg	Roy W. Lundberg	Walter F. Ross
Rev. Carl J. Bergman	Paul D. Holst	Donald E. Lundgren	Leonard Sjosten
Sterling Blackwood	John N. Hulslander	Leroy W. Madison	Harold P. Smith
Paul R. Blomquist	Richard L. Jandron	Frank H. Mangsen	William A. Stenmark
Ernest V. Borg	Carl W. Jarvey	Walter J. Mattson	Russell E. Strand
Axel Brod	A. Iver Johnson	Warren I. Moberg	Raymond E. Sundberg
Carl E. Carlson	Arne E. Johnson	Raymond E. Nyberg	Rudolph H. Ullstrom
Francis T. Carlson	Carl E. Johnson	Carl V. Orstrom	George Vogel
Arthur R. Creamer	Eric T. Johnson	Roger O. Pearson	John E. Wallgren
Sverra T. Dahl	Hugo A. Johnson	Malte G. Person	

KOREAN WAR VETERANS

Lawrence W. Potts

PEACE TIME VETERANS (ON ACTIVE DUTY AT TIME OF DEATH)

John A. Swenson

*Veteran of both World Wars. **Veteran of both Spanish-American and World War I.

The organization of the Swedish Cemetery Corporation in 1885 was unique. As can be best ascertained, it is the only known private, nondenominational cemetery organization established in the United States by Swedish immigrants. The original cemetery was dedicated on Memorial Day 1886, and in July 1922, the second burial ground was officially opened. Included among the thousands interred in the two cemeteries are the region's veterans. The above list of veterans was printed on the back of the 1958 Memorial Day program.

ACKNOWLEDGMENTS

We wish to thank the staff members at Arcadia Publishing for their professional assistance on this project. We are also grateful to the following individuals: Pete Petterson, Karin Fox, Thurston and Shirley Solomon, Millie Johnson, Helge Nordstrom, Esther Nordstrom, Doris Veach, Bob and Norma Belden, Nils Lundin, Lennart Soderman, Rigmor Wallace, Kenneth Hultgren, Jane Hedin, Nancy Oaks, June Stewart, Amy Lindbergh, May and Carl Granquist, Frances and Harry Gadde, Paul Nystrom, Joe Nystrom, Dottie Rayla, Frank Morrill, Lisa Betrovski, Carolyn Skoglund, Herbert Anderson, Robert Anderson, Penny Morway, Patty Nyberg, Eunice Nelson, Elaine Barrows, Robin Forsberg, Bob Stake, Kenneth and Norma Ahlberg, Helen Reneau, Richard Johnson, Kathryn Mangsen, Ronald Johnson, Lillian Hohler, Janet Peterson, Nancy Farnham, Edna Hill, Ruth Denman, Steven Magnuson, Barbara Ela, C. Eric Lysen, Nan Johnson, Wilbur Johnson, Wayne Lund, Joan Foss, Barbara Vanschermbeek, Allan Fant, Louise Fietz, Leif and Siw Kristiansson, Marion Grundberg, Helen Klimoff, Ruth Jensen, and Betty Becker.

We thank the following churches: Trinity Lutheran, Worcester; Zion Lutheran, Worcester; Belmont Street Baptist, Worcester; Christ Lutheran, West Boylston; Emanuel Lutheran, Fitchburg; St. Mark Lutheran, Woonsocket; Emanuel Lutheran, North Grosvenor Dale; Evangelical Covenant, Woodstock; Bethlehem Evangelical Covenant, Worcester; Salem Evangelical Covenant, Worcester; Emanuel Lutheran, Worcester; Epworth United Methodist, Worcester; and Immanuel Lutheran, Holden.

The following organizations and businesses were helpful during the research process: Swedish Cemetery Corporation, Swedish Social Club, Auburn Historical Society, Worcester Public Library, Worcester Historical Museum, Fitchburg Public Library, Fitchburg State College, Crown Bakery, Nordgren Memorial Chapel, the Gift Chalet, and Scandia Specialties.

Special thanks go to Tom, Marilyn, and Betty for their continued support and encouragement during the preparation of this book.